# CARTER LAKE

## · A SLICE OF IOWA ·
## IN NEBRASKA

JOHN SCHREIER

*To Bill,*
*I hope you enjoy this history!*
*— John Schreier*

THE
History
PRESS

Published by The History Press
Charleston, SC
www.historypress.net

First published 2017

Manufactured in the United States

ISBN 9781467118583

Library of Congress Control Number: 2016950687

*To my wife, Samantha: I may have written a book first,
but I know you will soon write one better.*

# CONTENTS

# ACKNOWLEDGEMENTS

First and foremost, my wonderful family helped push me while cheering me through the process of writing a book. Whether it was supporting me through the countless hours researching at the Council Bluffs Public Library, the work done while on a family vacation to the beach, or always supporting me through the process, I can't thank you enough.

As a newspaper editor, I had more access to our materials than any other. From the documents, I owe a debt of gratitude to my co-workers whose work I cited: Mike Brownlee, Kyle Bruggeman, Ashlee Coffey, Dennis Friend, Kirby Kaufman, Jon Leu, Chad Nation, Tim Rohwer and Joe Shearer—those who work alongside me and the forerunners at the *Daily Nonpareil* whom I never met but relied on. Their first draft of history helped tell this first draft of Carter Lake's story.

This book would not have happened without the two editors with whom I worked—but have never met. Greg Dumais saw the potential in a distant newspaper in far-flung Iowa when he stumbled onto my 2012 article on Carter Lake's confusing, colorful history. He advocated for the book's publication when it appeared to be in doubt. Ed Mack helped provide me the direction and stylistic points needed to ready this labor to become a reality.

Finally, the local historical community deserves much credit for this book. Ben Johnson at the Council Bluffs Public Library set aside documents out of the special collections and an advance preview of digitized archives. Adam Fletcher Sasse, a historian whose research covers the opposite side of Omaha from where I grew up, was ready to share research with someone with whom

he'd never corresponded in person. Dick Warner and Jon Barnes of the Historical Society of Pottawattamie County both provided me reference material nearly on command when I asked to pick their brains.

There are many other family members, friends and colleagues whose contributions to this book were not direct but helped push me toward completing it. For any of you whom I've missed, thank you.

# A GEOGRAPHICAL ODDITY

U nless you have a boat, the only way to reach the city of Carter Lake, Iowa, from elsewhere in the state is to travel through Nebraska.

This little peninsula often confuses travelers to Omaha's Eppley Airfield, located just a few blocks from the city limits and state lines. Those heading into downtown Omaha on Abbott Drive encounter a large "Welcome to Iowa!" sign as the road briefly becomes Iowa Highway 165, the shortest state route in Iowa at a half mile in length, before once again reverting to a Nebraska street.

The simple question is asked by many residents of both states: "Why is Carter Lake in Iowa?" The short and truthful answer is that the city has always been in the Hawkeye State. The reality, however, is far from that straightforward.

Iowa and Nebraska repeatedly battled for the city bordered by the new oxbow lake that resulted when the Missouri River changed its course in 1877. But to the stranded Iowa community on the west, or Nebraska, side of the river, neither Council Bluffs nor Omaha wanted Carter Lake for anything more than its tax revenue for decades.

Residents of Carter Lake pleaded with leaders of both cities, yet neither extended utilities and services into what was a literal and figurative island in the middle of everything. The area was once called Cut-Off Island—a fitting name for a place torn between two cities and two states yet connected to neither. The *Omaha World-Herald* once described the community in its earliest days as a "forlorn little settlement called Carter Lake, cut off from its

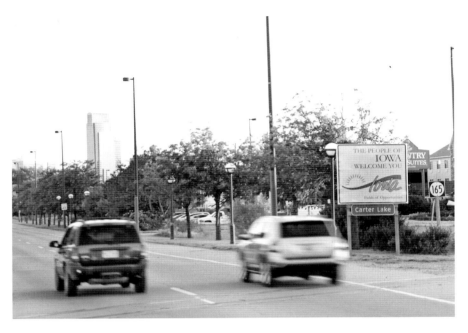

Cars zip from Nebraska to Iowa on Abbott Drive, which becomes Iowa Highway 165 at the point shown beneath the Omaha skyline. *Author photo.*

own state of Iowa by the rushing river, ignored as a foreign settlement by its Nebraska neighbors."[1]

Finally, in 1930, Carter Lake was incorporated as a city in the state of Iowa, a status it has retained ever since. The city has enjoyed a colorful, confusing history both before and after its incorporation. Carter Lake's search for identity resulted in several high-level legal disputes; the city fought for the ability to secede from Council Bluffs in the state supreme court, was the subject of at least two U.S. Supreme Court rulings and heavily influenced a third. To nearby residents, the town served as everything from a family-friendly amusement park to one of the Midwest's largest illegal gambling hot spots.

Today, Carter Lake remains firmly located in Iowa, but it continues to contribute to the principal cities on both sides of the state line. The city's students, for instance, attend Carter Lake Elementary School, which is a part of the Council Bluffs Community School District. A handful of homeowners backing up to the lake pay property taxes to both Iowa and Nebraska, as the state line cuts through a portion of their backyards.

Yet, amazingly little has been published about Carter Lake's history. Beyond an Omaha college student's dissertation submitted in 1960, I found no other

Carter Lake Elementary School first-graders Mason Cortez Trujillo (*front left*) and Joella Wingate (*front right*) practice identifying beats during a patron tour on March 19, 2015. *The Daily Nonpareil/Joe Shearer.*

works despite an exhaustive search across Iowa and Nebraska libraries when I first began writing this book. Little exists in the archives of both local and state historical preservation groups. Much of the source material came from contemporaneous newspaper reporting over the decades. In nearly every case, this first draft of history has been the most recent since the day it was printed—and the variety of sources led to occasional discrepancies on dates and players, which have been noted throughout. A handful of historical books about Omaha and/or Council Bluffs contain snippets about the town, but despite being considered a part of both at points in its history, Carter Lake has been firmly entrenched as "over there" by both cities.

Newspaper accounts over the years lean heavily on the phrase "over there" to describe its location. Carter Lake is often seen today as nothing more than a geographic outlier—one of many small pieces of land tossed back and forth between Iowa and Nebraska by the Missouri River's fickle flow over the years. But that status fails to do justice to the tug of war that birthed Carter Lake from floodwaters and continues to shape its history to this day.

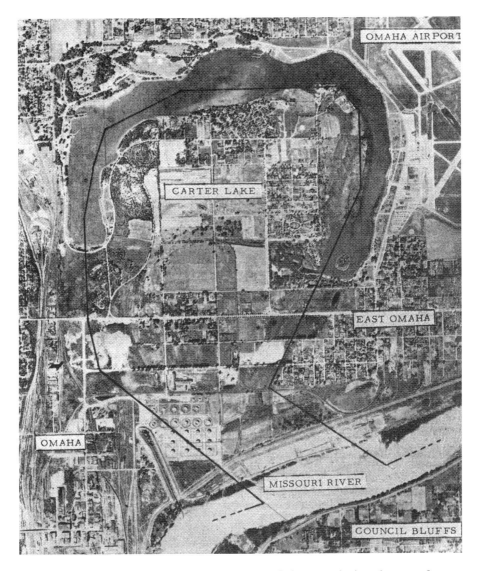

This aerial view shows how the community of Carter Lake protrudes into the state of Nebraska, completely separated from Iowa by the Missouri River. *Pottawattamie County Engineer's Office, reprinted in the* Daily Nonpareil..

As David Harding, a history columnist and correspondent for the *Omaha World-Herald*, wrote in 2010: "Depending on your perspective, Carter Lake is either a feisty little Lichtenstein [*sic*] squeezed between Nebraska and Iowa or a gallstone in Omaha's gut. Either way, the

town of 3,200 souls deserves respect for having survived its history of geographic and political whiplash."[2]

To ask "What is Carter Lake?" or "Where is Carter Lake?" is a far larger question than a casual observer might realize. In a literal sense, according to the report for a recent project to renovate the lake that shares its name with the neighboring community,

> *Carter Lake is an oxbow lake that lies in Pottawattamie County, Iowa, and Douglas County, Nebraska. In 1877, flooding and shifting of the Missouri River created the oxbow lake. The lake is located directly west of Eppley Airfield and about two miles from the Omaha downtown area. The City of Carter Lake, Iowa, lies completely within the concave portion of the lake and the City of Omaha and Levi Carter Park surrounds the lake on its convex side.[3]*

While the previous paragraph is entirely accurate, it omits much of the community's tale by its brevity. Carter Lake tells the story of what happens when nature yet again proves that it is stronger than the arbitrary nature of political boundaries. Though it may have been a fleeting victory for the Missouri River, whose force has since been by and large contained through the engineering feats of man, places such as Carter Lake "reveal the trouble of our manner of bounding. We force permanence on dynamic changeable geographic phenomena. We belong to names not places; we are thoroughly gentilic."[4]

The earliest residents of this aptly named Cut-Off Island lacked even a concrete name or identity for a community that was often battered by the elements. Though it no longer had a physical connection to Council Bluffs, it remained a part of Pottawattamie County's largest city. Conversely, the land was now on the Nebraska side of the river yet, despite that proximity, did not even share the same state as the land that now enveloped it on all sides. And the largest city in that state, Omaha, failed to embrace Carter Lake as its own despite the smaller community's explicit desire to be absorbed into it.

For its entire history, Carter Lake has been a place with an identity not fully its own, owing to its proximity to the much larger cities that have influenced its history. As its mayor told the *New York Times* in 1988, the city has been "treated like an orphan" from neighbors on both sides of the river for most of its history.[5] But it cannot be questioned that much of its personality was a product of the plucky people who developed a community that owed its very existence to a squatter in the swamps, as "the unique historical and

13

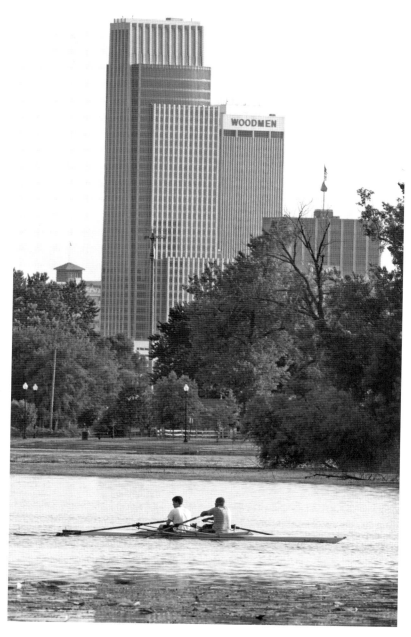

Downtown Omaha stands behind members of the Omaha Rowing Association skimming the surface of Carter Lake. *From the* Omaha World-Herald/*Kent Sievers.*

developmental characteristics of Carter Lake significantly affected the types of human behavior which took place within this particular community."[6]

All that remained for Carter Lake was to push forward as it always had. Founders forged ahead using the same unilateral, independent means that pushed the city from the swampy finger of the Missouri River into a settlement that had a local identity but lacked a state of mind—and a literal state of being—for decades. Instead, Carter Lake became a punchline and stereotype for residents of Nebraska and Iowa, failing to shake off its earliest days as a haven for the scoundrel and gambler long after the institutions protecting both had been exorcised.

Since the day it was formed by the Missouri River, Carter Lake has been a paradox. Most visibly, the city is a part of Iowa despite being firmly planted on the Nebraska side of the river. But the juxtapositions run far deeper. The lake from which the Iowa community draws its name, one that has far more surface area in Nebraska, memorializes an Omahan. The wealthy doctor who owned the land now occupied by the city of Carter Lake squatted in a shack to guarantee his claim. Once the haven for the scoundrel and gambler, it is a bedroom community. This is a suburb near Omaha's inner city—one that has battled high crime rates yet offers far more parks and family recreation than most cities of a comparable size. Unwanted by Omaha, Carter Lake elected to govern itself, only to soon find itself in the crosshairs for Nebraska officials.

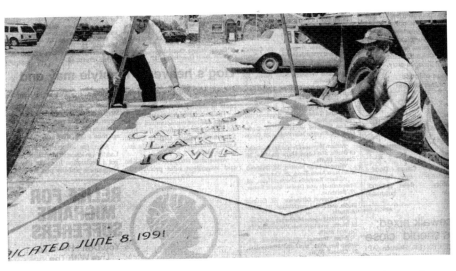

John O'Conner (*left*) and Mike Eckrich of B.F. Bloom & Company help unload a granite sign in Carter Lake on Saturday, June 8, 1991. *From the* Daily Nonpareil/*Steve Giowacki.*

A horse pulls a sled to clear the snow off Carter Lake so that its ice can be harvested and sold to Omaha residents, 1916. *From the* Omaha Daily Bee.

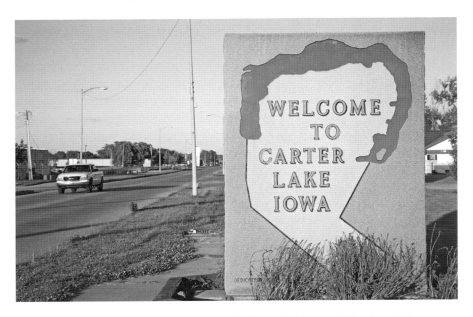

A truck heads westbound along Locust Street in Carter Lake toward Omaha, driving past the Iowa city's welcome sign. *Author photo.*

Despite attempts by Iowa to divorce itself from Carter Lake, its residents more firmly than ever desired to remain in the Hawkeye State.

Over the years, the town of Carter Lake has been described as many things. The same reporter for the *Daily Nonpareil* described its shape as a "foot…cut across at the ankle"[7] and like the "sheared off head of a golf club that someone put in the wrong bag."[8] In its earliest, more blue-collar days, a sociology student

believed the town's "lowlands, dumps, smoke, smells, beer taverns" merited the word "unsightly" three times in one sentence.[9] One mayor likened the surrounding communities' ignorance of Carter Lake to that of "an abandoned child…sitting on Iowa's back for more than 100 years."[10]

Despite the negative press, to Carter Lake's residents, it truly is "a little Iowa oasis in Nebraska."[11] The lake from which it drew its name, too, was long regarded for its natural beauty and called the "finest water" in the region, once harvested for its ice.[12] Today, many residents feel like they are "living in a resort," with a small town alongside a picturesque lake.[13] Carter Lake residents, even in its earliest days, viewed their city with "a lot of pride in their town."[14] The first city attorney called Carter Lake a "bonanza" for Iowa—and its residents most certainly agree, quite happy to play just that role.[15]

Though the following line was written in 1960, just three decades after Carter Lake was incorporated, it remains true to this day: "To the majority of people, Carter Lake is not a town; it is a name, a name with many connotations, but few of these connotations are accurate pictures of the community."[16] This book aims to paint the most complete picture of this colorful community, one crafted out of long-standing geographic uncertainty and the will of its people to become and remain a city in Iowa.

# 1

# CARTER LAKE

## *Founded as an Outlying Portion of Council Bluffs*

Council Bluffs resident Thomas Jefferis, a prominent doctor in the city, wore many hats in the city's earliest days after its incorporation in 1853. He was a noted land speculator, a common practice locally after the Mormons, the city's first permanent residents, moved west toward present-day Utah from the city they founded and sold thousands of acres of land in western Iowa to fund the journey.

Jefferis's medical skills were highly regarded—or at least billed as such in newspaper advertisements from the era—but it goes without question that he set up one of Council Bluffs' first apothecaries, if not the first, and was often seen "searching in out of the way places and obscure corners for choice herbs."[17] An ad that appeared frequently in the *Omaha Daily Bee* in 1884 told of how "the records of mortality show that Dr. Jeffries [*sic*: a common misspelling of his name] is the most successful practitioner of medicine in the western country." A brief in the same newspaper a year later noted "[t]here has not been a death from diphtheria in over five years where Dr. Thomas Jefferis Preventive and cure was used. It has saved thousands of lives."[18]

Even away from his medical practice, Thomas Jefferis, a native of Wilmington, Delaware, was a pivotal and colorful figure in early Council Bluffs. The new settlement was low on currency and coin, meaning little to no business could be done. Instead, Jefferis created his own, printing "green time checks good for trade in various stores of the community" that "for a time were almost the only circulating medium."[19]

A 1979 article in the *Daily Nonpareil* describing another of Jefferis's many talents can best be summed up by its headline: "The good doctor made booze, too." The newspaper detailed the short history of his homemade whiskey distillery. In a tower estimated to be sixty feet tall, he cut a small hole to fit a tube made of a maple branch. When he was "ready to indulge his thirst…he'd insert the improvised tube. It would then be a simple matter to drink to his heart's content."[20] His still was eventually closed down and sold to an Omaha distiller that used it for many years.

But perhaps Jefferis's most notable contribution to the region came from his dogged determination to maintain a piece of land he purchased near the river—one that ultimately became a part of Carter Lake.[21] In the end, his unyielding persistence to hold on to his property was among the major factors that helped keep the city in Iowa.

Jefferis and his brother Edmund had once operated a steam mill along the Missouri River west of Council Bluffs near present-day Carter Lake. Though Edmund later moved to rural Pottawattamie County east of Council Bluffs, Thomas maintained ownership of the river land, which today remains a part of that same county—despite many efforts to the contrary.[22]

On this land, Thomas Jefferis had the first steam engine ever seen in Council Bluffs brought to his mill, hauled by a team of eight oxen nearly twenty miles from a stranded steamship in Mills County to the south and "upstream where it was welcomed by a large throng almost as large as the entire population of Council Bluffs."[23] The new addition turned what had been among the "crudest and most simple" of mills, formerly powered by alternating human saws, along the Missouri River into a critical driver for a housing boom in Council Bluffs by producing cottonwood sills, joists and lumber for these new homes.

Jefferis had claimed thirty acres of "swampy bottom land" west of Kanesville, an early name of Council Bluffs given by Mormons headed westward before the city's incorporation.[24] On the Nebraska side of the river, too, Thomas Jefferis owned a large section of what would become northern portions of downtown Omaha and, later, the then-separate community of South Omaha. Furthermore, he owned a sizable chunk in Monona County, Iowa, some seventy miles to the north of Council Bluffs and several parcels of land that would later be platted into Council Bluffs.[25]

As the Missouri River channel gradually shifted west in the subsequent years, this particular land holding increased in size by more than 150 percent to seventy-eight acres. But the same river that added to Jefferis's investment also took it away, as the sudden shift in its course in 1877 left nearly 1.5 square

miles of land that had been in Iowa on the Nebraska side of the river, with a crescent-shaped lake marking the northern boundary of what had been its previous path. As Helen Aulmann, a prominent Carter Lake resident and local historian, told the *Daily Nonpareil* in 1976, Jefferis's "land was not in the middle of that horseshoe bend and was pretty much considered part of Council Bluffs"; instead, it was much closer to what had been the river, the logical place for a mill.[26]

However, the prominent doctor would not be defeated by Mother Nature.

The *Daily Nonpareil* relayed an anecdote in Jefferis's obituary that Finley Burke—a leading Council Bluffs attorney who married Jefferis's eldest daughter, Parthenia—came across some documents regarding a claim to land on what had become known as Cut-Off Island. Dismissed by his father-in-law, who assumed "in all likelihood, the land had long since been sold for taxes," Burke instead discovered in 1882 that Jefferis indeed maintained ownership of the former mill property.[27]

In response, Jefferis reportedly spurned his "veritable mansion" on Sixth Avenue in the heart of Council Bluffs to claim his residence on the disputed island that was once home to his mill.

Several versions of the story about Jefferis's exact actions—and the spelling of his last name, which is often inaccurately written as the more commonly seen "Jefferies"—exist. Many more contemporaneous accounts incorrectly attribute the land as Edmund's, as he helped make the original land claim. But one thing is for certain: Thomas Jefferis exercised squatters' rights and won a protracted legal battle to keep the land from developers who wanted to claim the area for Omaha. When the river avulsed its banks in 1877, it left the state lines in flux, although the U.S. Supreme Court would later rule the borders had never changed, despite the river's sudden shift in course.

One of those anecdotes is relayed in *The History of Pottawattamie County*, a 1907 work: the story of Jefferis's death in 1895:

> [Jefferis] *followed his land, squatted on it, and as fast as they would evict him, return, and commenced proceedings in the United States court and at last won out, and that piece of land with the resort of Portland Beach forms a precinct of the sixth ward of Council Bluffs, although on the west side of the river and almost surrounded by Nebraska.*[28]

Jefferis's dogged claim to the land that became the city of Carter Lake came despite several legal setbacks, including one in 1889 in which a judge reversed his own earlier ruling about who owned the plots following the

avulsion in a decision the *Daily Nonpareil* newspaper predicted "will affect disastrously the interests of over two hundred property owners, many of them having invested nearly their entire fortunes there."[29] At this point, the Council Bluffs doctor's determination to protect his investment seemed to be the only thread tying Cut-Off Island to Iowa. And though he was delayed in achieving this goal, Jefferis was eventually vindicated by the Supreme Court's 1892 decision nearly fifteen years after the Missouri River changed its course.

As was so often the case in the land dealings of Jefferis—a man about whom the *Nonpareil* said "at this time, everything he touched seemed to turn to gold"—he turned a substantial profit from being in the right place at the right time. Shortly after the court ruling that favored his claim, he sold all but forty acres of the land for $8,600. Lots on Jefferis's remaining property appreciated in value so much that they would later sell for as much as $1,000 apiece.[30]

From this, the earliest foundations of Carter Lake were formed from the fruits of his prolonged fight. Maybe, then, it is fitting that the *Nonpareil* devoted much of the beginning of Jefferis's 1895 obituary to his roots as a settler and pioneer, given his role in forging what would many years later become an independent city in his adopted state of Iowa.

The newspaper noted the enterprising doctor, businessman and land speculator was a "remarkable figure" and the descendant of Quakers, "the peaceful yet mighty followers" who moved with William Penn to the New World. Accordingly, the newspaper wrote, "This fact accounts for the sinewy strength of character that so marked the man who came west in the pioneer days to a county that was as lone and barren as a desert in its original state, yet capable of extraordinary development."[31]

## 2

# MISSOURI RIVER CHANGES COURSE, BORDERS AND HISTORY

Bluffs of fine loess soil, the remnants of glacial till from eons ago, line the Missouri River's eastern bank in Iowa. On the river's west side, the hills coming up from the waterfront were originally so steep they had to be cut at a more gradual angle by early settlers to allow horses tethered to carts or buggies to climb the slopes and continue westward. Those first settlers, who likely chose to build their homes and communities along the river because of its ability to sustain lives and economies, soon learned its wrath. As an Omaha writer who chronicled the unmatched flood of 1952 said in his postmortem,

> The Missouri is the nation's longest river, 2,464 miles* from Three Forks, Montana to St. Louis, a turbid stream where water is thicker than blood. An Iowa farmer said it was "too thick to drink and too thin to plow." The man who knows the Missouri best, Lt. Gen. Lewis A. Pick, retired chief of army engineers, has called it one of the wildest on earth.[32]

> * The Missouri River is actually measured at 2,341 miles from the confluence of the Jefferson, Gallatin and Madison Rivers in Montana, the point at which Lewis and Clark designated its beginning in 1805. However, when measured from the actual headwaters—Brower's Spring in Montana, discovered in 1890—the river's length is extended by 298 miles to 2,639 miles.[33] For some reason, the Lewis and Clark measurement remains more commonly used today.

Today, the river is far narrower and deeper than it was when Congress set the middle of the channel as the boundary between Nebraska and Iowa in 1864. As a major route for shipping, the Missouri has "been sweepingly transformed, primarily during the past century, from a wide, relatively shallow and highly dynamic mobile system to an intensively engineered channel, primarily in order to facilitate riverboat navigation."[34] Other renovations have focused on flood prevention, generally successful attempts to preserve farmland and burgeoning populations in the sizable river valley. One-sixth of the North American continent lies within the Missouri River basin.[35]

A series of dams have turned the Missouri upriver from Gavins Point Dam along the South Dakota–Nebraska border into what resembles "a series of standing lakes"—a far cry from the fast-flowing river seen by the area's first settlers.[36] As the *Omaha World-Herald* said in 1934, "They're putting the crazy old Mizzou in a straight-jacket. Up and down the river, government engineers are throwing up rip-rap here and laying down mattress there to keep the old gal in her place."[37]

Until the late 1800s, the area surrounding the river was mostly flat: a floodplain tossed about under the annual spring melt. The braided channel took the path of least resistance as it wound its way south toward Missouri, trading its current route for a new one on a whim. Two Omaha newspapers waxed poetic to explain the force—and devastation—this river could wreak on their city before its taming:

> [T]*he Missouri, born in the mountains and big with the freedom of the glorious wildness of nature that surrounds its nativity, has always resented man's puny efforts to fix for its channel metes and bounds. It…sweeps its course through the greatest alluvial plains of the world, laughing at every attempt to restrain it. Its ways have been the despair of hydrographers and engineers, and its meander has been the undoing of the official records of every commonwealth touched in its course. Its whims are the unreasoning ones of a child of nature, untrammeled by civilized conventions and undaunted by musts and must nots. It is the Big Muddy and a law unto itself.*[38]

> *Sometimes, she played little kittenish tricks, like snatching a rowboat from the shore, but again, in a vixen mood, she has menaced whole towns with her ruthless power. She has swallowed up the work of year for one man in a single gulp, and spewed it, as a gift from the gods, on another's shoreline. She has stopped trains, killed crops, ruined homes.*

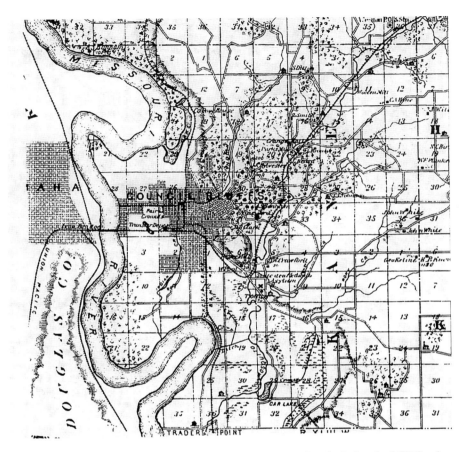

This map shows the Missouri River between Council Bluffs and Omaha before the 1877 flood, with Saratoga Bend visible in Section 21. *The Historical Society of Pottawattamie County.*

*She has isolated whole sections in a No-Man's land, disowned by states on either side. She has driven neighbors—and even states—into court.*[39]

Whenever the river overtopped its banks and rushed into farmland and portions of the young cities of Omaha and Council Bluffs, it brought with it sand, silt and other sediments. The accretion of sediment bandied land back and forth across state lines. The costs of constant flooding were felt on both banks, as "[t]he stream gnawed into its banks, sometimes eroding fertile farmland at the rate of 2,000 feet per year. As the Missouri eroded one bank, it tended to drop silt on the opposite side and build new land."[40]

Subsequent "engineering modifications of the Lower Missouri have focused on constricting and straightening the channel in order to maintain minimum navigation depths, armoring of the banks to prevent lateral erosion, and construction of levees to exclude flood flows from the floodplain."[41] But, in 1877, the Missouri River near Carter Lake was just beginning to be studied by the experts of the day when everything changed.

A massive ice gorge came to rest and blocked the Missouri River at a bottleneck just north of Council Bluffs and Omaha on March 16, 1877. An unstoppable force had indeed met an immovable object. The river's current began to push its way around the impediment. Buoyed by high waters in June and an "unprecedented rise" in July, a new channel began forming.[42] Just seventeen days after Max Boehmer, a civilian assistant engineer with the U.S. Army Corps of Engineers submitted a report—the culmination of a month's work—to Major Charles Russell Suter, the Missouri River avulsed its course and burst through its banks. A four-mile meandering half-circle of river, Saratoga Bend, was left orphaned on the Nebraska (west) side of the river when the path suddenly straightened on July 8, 1877.

As it so often did in the 1800s, the Missouri River changed its course dramatically, digging a new river channel "with violent erosive action."[43] When the waters shifted, a crescent-shaped body of water called Cut-Off Lake was all that remained of the river's previous channel. The end result was a textbook avulsion in that it left a "scar or oxbow lake in its former position" at Saratoga Bend.[44] Accordingly, this lake was ideal for swimming and boating after its unexpected formation, as "[t]he bottom of the lake is as solid as a rock and covered with a fine sand."[45] Carter Lake is far from the only oxbow lake—a former river channel left as a body of water—after a change in the river's course; it is only "one of many oxbow lakes formed when the Missouri went on a rampage."[46]

The nearby river that created Carter Lake continued to confound. Years after the Missouri River chewed its way through the path of least resistance and marooned part of Iowa on the wrong geographic side of the border, the *New York Times* appeared bemused by the dedicated but ultimately futile efforts of the Army Corps of Engineers in the earliest attempts to control the Mighty Mo. "[M]uch money has been expended for the improvement of that stream, which has almost been so much money thrown away, so erratic is it."[47]

In the late 1800s, "the old time June rises and July floods…[ordinarily] were due to the thawing of mountain snows," the *Omaha Daily Bee* reported in 1905. "The water would then be liberated and rush down the tributary

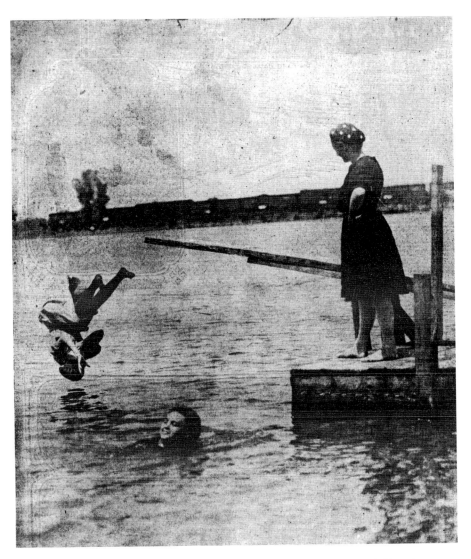

A girl dives off a dock on Rod and Gun Club beach into Carter Lake, 1910. *From the Omaha Daily Bee.*

source streams in torrents and the Big Muddy would go on its June boom." Just four years after the Missouri River broke through Saratoga Bend, it unleashed a devastating flood that crested in Omaha at 34.22 feet in 1881 and left Cut-Off Island under several feet of water. This remains the third-highest crest ever recorded in the area.[48]

The cause of most floods along the Missouri River from the late nineteenth century to the middle of the twentieth century came from heavy snows upriver, in Montana and the Dakotas, followed by unseasonably warm spring weather. With the melting of the snow accentuated by spring downpours, more water barreled to the south and east—toward Iowa, Nebraska and Missouri—than the still-primitive levee system could handle.

With its twists and turns, even accounting for the bottlenecks like the one at Saratoga Bend that have been blasted through, the Missouri River still stretches a distance that rivals the width of the continental United States. To provide an example of the size and scope of the nation's longest river:

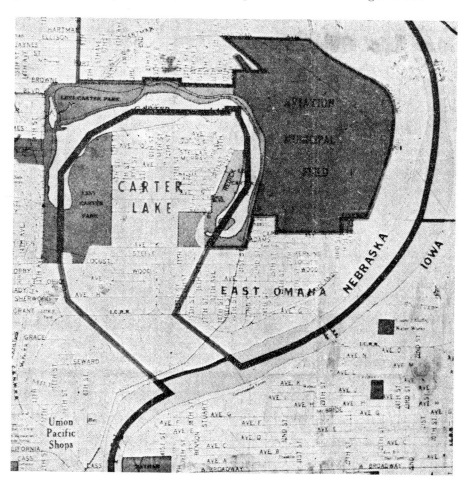

The black line shows the path the Missouri River once followed, which now cuts across the neck of the area, leaving Carter Lake in Nebraska. *From the* Daily Nonpareil.

*Were we to follow one that dropped from the sky into Brower's Spring, it would flow along the 298 miles from the spring to Three Forks. Then it would continue another 2,341 miles to St. Louis, where the Missouri meets the Mississippi. From there our drop would travel 1,003 miles to New Orleans, after which it would travel an additional 103 miles before finally depositing itself into the Gulf of Mexico. The total distance is 3,745 miles, making this great American river system the world's third longest, after the Nile and the Amazon.*[49]

Despite the ongoing threat of another avulsion, the Missouri River has maintained roughly the same course near Carter Lake. The taming of the river by the U.S. Army Corps of Engineers for the purposes of flood prevention and maintaining navigability has preserved that route for more a century.

Increased irrigation of cropland, much of which could be farmed without fear of flooding after improvements to the river, also helped tame the river. Water pulled from tributaries or the river itself was transported to cultivated ground, which in turn "permits the percolation of the moisture into the soil instead of running off from the former hard baked surfaces."[50]

But by no means was the 1877 avulsion the end of the flooding in Carter Lake. Minor flooding was a nuisance to residents for decades to come, and at least three major floods—1881, 1943 and, most notably, 1952—led to evacuations of portions or the entirety of the city. Despite the annoyance of the river's occasional run through the city, those residents owed the community's entire existence to that water, as it can truly "be called the town the Missouri created."[51]

## 3

# TUG OF WAR ENDS UP IN SUPREME COURT

With its braided channel before the present dams and flood control systems were implemented, the Missouri River routinely flooded and changed its course. The old river could change its course at will over the span of nearly four miles, from downtown Omaha to downtown Council Bluffs, with the present-day Council Bluffs neighborhood known as the west end squarely in the middle.

But few, if any, of its unexpected reroutes were as dramatic as the straightening of its path that left an oxbow at the former Saratoga Bend so cut off from its new route. Since the day it was created, "Carter Lake has been a mapmaker's nightmare."[52] This small horseshoe-shaped lake and adjacent pieces of land still confound lawyers and laymen alike, although the true location of Carter Lake has been set in stone for more than a century.

It took something as seemingly arbitrary as an enterprising bar owner attempting to flout not one but two states' liquor laws with a watering hole floating on the lake's waters to bring the defining legal closure in determining which state could lay claim to Cut-Off Island.[53]

But, in the end, Carter Lake's story always comes back to perceived uncertainty regarding geography—the same situation a floating saloon sought to exploit.

Officials with both the City of Omaha and State of Nebraska presumed the land that had essentially washed up on the west bank of the Missouri River was now theirs. Under the law of accretion, soil that accumulates across a border designated by a river becomes the property of the receiving

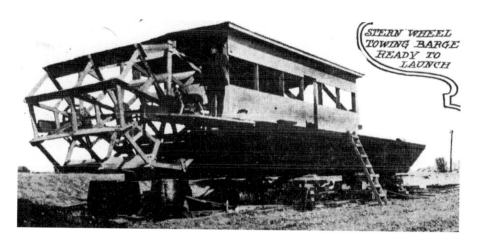

A barge is under construction, awaiting use as recreational opportunities on Carter Lake grow in the early 1900s. *From the* Omaha Daily Bee.

state. Operating under that assumption, they planned for rail lines and manufacturing in the low-lying flatlands just northeast of downtown Omaha. Many maps from that era make no mention of the land as either Council Bluffs or Iowa; rather, the area is referred to as "East Omaha," a term that persisted in newspaper reports until the late 1920s.

Council Bluffs officials, however, saw Omaha's intrusion as a brazen attempt to snatch land that rightfully belonged on their tax rolls. The land now on Nebraska's side of the river did, in fact, start in Iowa before being forcefully moved en masse, they argued. The ensuing legal battle over whether Iowa or Nebraska had jurisdiction over Cut-Off Island ultimately went to the Supreme Court—and confusion reigned supreme.

Further convoluting the topic are the differing laws between Iowa and Nebraska regarding property rights along and under a riverbed. A century after the Missouri River's avulsion, the curious case of Carter Lake was cited in the Nebraska Law Review in 1877 regarding an area of land called Blackbird Bend some seventy miles to the north: "In Nebraska, the riparian owner owns the river bed adjacent to his land to the thread of the stream, or the 'thalweg.' But, in Iowa, the state owns the bed of the stream to the thalweg and, therefore, claims any islands rising on the eastern half of the Missouri."[54] The terms "thread of the stream" and "thalweg" are widely used legal terms in Nebraska to represent the deepest portion of the channel, which is generally in the center.

In one instance that highlights the lack of certainty over the border, a judge reversed his stance in separate rulings regarding Cut-Off Island.

A Justice Brewer who had previously ruled in favor of Thomas Jefferis in an earlier case wrote in 1889 that he had incorrectly applied the law of accretion. In his decision, Brewer stated: "[When] I ruled in favor of the defendant, I am constrained to believe that I erred within....[T]he Supreme Court seems to have laid down this proposition that, where a water line is the boundary, no matter how it shifts."[55] Instead, the justice the *Omaha World-Herald* called "a good Nebraskan" had "been overruled by his colleagues," with his ten-page decision little more than a dissent.[56]

On that point, Nebraska based much of its argument. The Missouri River had been set as the boundary between the state and its eastern neighbor, Iowa. Because its course had moved, the state line should be shifted with it—a move that would've given Nebraska this significant chunk of new land. In this case, had the river instead gradually moved the land now occupied by Carter Lake to the waterway's west bank, the community would be in Nebraska—and this book would almost certainly not have been written. But, as is noted in the Troposheric Aerosol Library:

> *If the river changes slowly, moving sediments from one bank to the opposite, the border slowly changes with those newly created lands. If done piece-by-piece, particle-by-particle, each one changes from Iowa to Nebraska upon arriving at the new bank. But if the change happens suddenly, and all at once, the border remains the same. What was once Iowa remains Iowa, in spite of it no longer connecting to Iowa.*[57]

In its 1892 ruling, the Supreme Court—the first and only court that can hear cases in which one state sues another—upheld the idea that the state boundary was in the middle of the river. However, a corollary of the ruling sided with Iowa on the basis that state lines remain the same when a river avulsed, or dramatically altered, its path in 1877. Therefore, in a ruling that confounded many in that day and age, the land had never left Iowa, despite its position on the Nebraska side of the river.

One of the best, most succinct assessments of the court's ruling came nearly a century later in an editorial in the *Omaha World-Herald*:

> *The court dealt specifically with the competing claims of Nebraska and Iowa for 1,300 acres of Iowa land that wound up on the Nebraska side of the river after an 1877 flood in which the Missouri cut a new channel. The decision hinged on the court's analysis of what had happened during the flood. Land that is washed from one state to another becomes part of*

*the receiving state, the court said. In the case of Carter Lake, the Iowa
land remained stationary while the river changed positions. Under such
circumstances, the court said, the land remained part of Iowa.*[58]

But Carter Lake is not alone in its unusual geography—not even in
Nebraska.

An estimated "twenty-five areas of Iowa land and six pieces of Missouri
land are west of the river, while some thirty-two areas of Nebraska land
are on the Iowa side of the river and nine on the Missouri side." These
account for roughly twenty-eight to twenty-nine thousand acres in total.[59]
To illustrate the widespread nature of these border-defying slices of land
while proposing federal intervention to solve this "problem," Iowa attorney
general Tom Miller said in 1989 that a boat traveling on the Missouri River
between Sioux City and Council Bluffs, roughly one hundred miles to the
south, would cross state lines twenty-six times.[60]

Among the most well known of these more than seventy anomalies is
McKissick Island in southeastern Nebraska, some ninety miles south of
Carter Lake.

Nebraska had once before fought to keep an area of land that swapped
sides of the Missouri River. In this case, Nebraska found itself on the opposite,
well, bank. The region in question, McKissick Island, was originally part of
Nemaha County, Nebraska, before an 1867 flood caused the river to avulse
its course westward. The flood straightened a bend in the river, leaving the
island on the Missouri's east bank.[61] Missouri claimed the displaced land
as its own, taking the case to the Supreme Court in 1904. But the high
court ruled definitively in Nebraska's favor, as Justice John Marshall Harlan,
heavily citing the Carter Lake case among others, wrote in his decision: "The
former decisions of this court relating to boundary lines between states seem
to make this case easy of solution."[62]

Now essentially devoid of population after repeated flooding, McKissick
Island has seen the circumstances forcing its reliance on services two states
away subside. Gone are the days of decades past when mail was delivered
to this exclave from Iowa through Missouri and the need for school buses
to carry insurance in three states, as Nemaha County students were bused
through Missouri briefly on their way to Iowa.[63] A 1999 congressional
resolution gave a small portion of land from this misnomer of an island
to Atchison County, Missouri, though the vast majority remained in
Nemaha County. Another resolution decreed the land, in perpetuity, as a
part of Nebraska.

Today, McKissick Island has the postal address of the nearby town of Hamburg—in Iowa, of course—and is accessible only from Iowa and Missouri roads. Yet it remains a part of the Cornhusker State. The inverse is true of Carter Lake, accessible only by Nebraska roads despite its Iowa address.

As Ehrlich noted in 1973,

> *McKissick's* [sic] *Island and Carter Lake are distinguished from the other anomalous areas along the Missouri River…by the fact that they contain considerable population, all of whom must cross the territory of at least one neighboring state to reach the main part of their own state. No bridge crosses the Missouri at either point.*[64]

Other than the "considerable population," which has since moved away from the oft-flooded McKissick Island, this observation remains accurate, more than four decades after it was written. The culture of these lands on the perceived "wrong" side of a border often become hybridized,

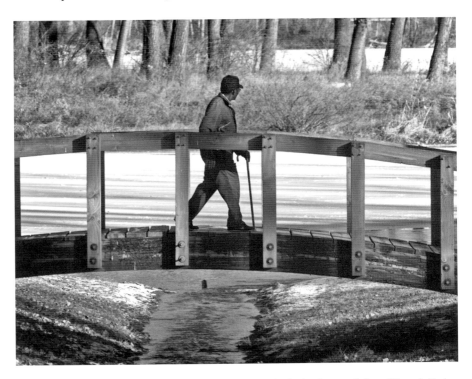

Billy Jones crosses over a bridge separating Carter Lake (in the background) from Kiwanis Park on one of his three walks around the park, 2000. *From the* Omaha World-Herald/*Bill Batson.*

torn between loyalties to its actual location and the one that makes more geographic sense.

This statement, originally written about Carter Lake in 1998, has been fitting for this community that has long been a part of Iowa despite its apparent physical location in Nebraska: "Exclaves are disconnected physically from a governing body, and from the rest of themselves. Their borders are uncommon with common land. They are disconnected of easy and immediate access; they are islands in the land."[65]

The Supreme Court ruling in 1892 set the precedent that was applied to these other exclaves, most being no more than mere spits of land, along the Missouri River. But, as would be noted in another case between Nebraska and Iowa eight decades later, "experience showed that 'the fickle Missouri River…refused to be bound by the Supreme Court decree [of 1892.]'"[66] And while its impact remains the same to date, its clarity was in question for many years—surviving many attempts from Nebraska to reclaim land some still believe belongs within its borders. Even in 1901, the *New York Times* accurately predicted issues would linger with the murkiness of the Carter Lake ruling, even mistaking what would become the Iowa city as part of Omaha nearly a decade later:

> [B]*y a peculiar wrinkle of the judicial mind, the same Supreme Court was able to formulate an addition to this decision by which the changing boundary clause was not effective in cases of "cut-offs," which has left the matter in such condition that no one, not even the lawyers, has been able to understand it. According to the Supreme Court, a portion of Omaha still remains in Iowa, although the boundary between the two States, by this same decision, is a mile or more to the eastward.*[67]

And, as the newspaper foresaw, the uncertainty surrounding the true borders between Iowa and Nebraska in the area of Cut-Off Island was ripe for exploitation.

# OMAHA BUSINESSMAN'S WIDOW GIVES NAME TO CARTER LAKE

What is now known as Carter Lake carried several names over the years, with the two most widespread being Cut-Off Island, owing to the area's origins in Iowa before the river avulsion, and Lake Nakoma (or Nakomis, by some accounts). The latter was taken from the wife of Peter Sarpy, a prominent fur trader from Nebraska's earliest days and namesake for a nearby county.

The lake and the town itself assumed the name Carter Lake in 1909 after the widow of Levi Carter donated significant amounts of money and land along the shoreline to the city of Omaha. However, despite Carter's influence throughout the area, city officials have no concrete marker to honor the pioneer and industrialist whose success and philanthropy paved the foundation for a city that now bears his name. A profile that appeared in the *Omaha Daily Bee* in 1908, five years after his death, describes him as the "personification of benevolence" and an "inexhaustible storehouse of nickels and dimes" for the boys he often visited fishing along the shoreline.[68]

Born in New Hampshire in 1830, the carpenter by trade decided to try his hand at freighting across the West—a lucrative business he continued nearly until his death in 1903. Buoyed by financial success from both endeavors, he invested in the construction of the Carter White Lead Works, which opened its doors on South Twentieth Street in Omaha in 1878 and expanded again in 1881. An 1882 book by A.T. Andreas attributed the doubling of its revenue in just a couple years to the quality of its product, noting, "The article of white

A portrait of the namesake of Carter Lake, Levi Carter, 1908. *From the* Omaha Daily Bee.

lead manufactured is of a superior class, equal in quality to that made anywhere in the United States."[69]

The plant closed in 1885 because of drastically reduced prices for white lead. However, Carter—ever the innovator—not only found a way to reopen the facility, buying out the original investors, but also revolutionized the production of white lead in the process. Until then, the process had been known as the "Dutch method."

> *He had been doing more than visiting the office of the company occasionally. He had laid aside his long black coat and his white shirt and collar occasionally and had donned overalls and gone down into the works and studied the method of manufacture.... [T]he process of making white lead used for several hundred years was known as the "Dutch process." Sheets of lead were placed in vats where they underwent an extensive corroding process, which took a long time. Levi Carter had studied the problem and he had decided that if the lead were reduced to atoms instead of being allowed to remain in large sheets the corroding would take but a comparatively short time. He experimented and found that his theory was correct.[70]*

The industrialist bought out his partners in 1889 and reopened the facility that January, expanding its operations again later that year after finding success following Carter's new method of manufacturing.

Though a disaster once again struck the plant—this time, an 1890 fire that burned the plant in South Omaha to the ground—Carter once again grew his company bigger and better in response. Within a month, he'd drafted plans for a new plant in East Omaha, one that would open

in late 1891. The new complex was said to house "21 buildings at the new plant, which was located at North 21st Street East and North 22nd Street East, between East Locust Street and Avenue J."[71] (Today, the area is, rather unsurprisingly, a Superfund site, owing to large levels of lead in the soil that "pose unacceptable human health risks for recreational and residential use under its current and future use conditions.")[72]

In addition to the white lead production, Carter's facility was involved in "the manufacturing of prepared paints and colors, to a large extent."[73] This would foreshadow the ultimate fate of his company. In the end, Carter's factory "succumbed to improved modern transportation methods, which made importation of white lead cheaper than local production."[74] This closure ultimately foreshadowed the disappearance of many of the other industries and business in the Carter Lake area in the years that followed.

In 1908, when the *Daily Bee* article was written, Carter White Lead Works had become the largest independent producer of white lead in the United States, with about two-thirds of its operations in its Chicago facility—which, in 1903, the *Nonpareil* reported was "turning out the largest output of any single white lead plant in the world"[75]—with the remaining third in East Omaha. Throw in his other businesses and land dealings, and Carter died a wealthy man despite the financial tragedies that would have ruined many other men.

"This is a typical example of the energy and courage of the man," the *Daily Bee* wrote. "Achilles-like, he was proof against the arrows of misfortune."[76]

More than three decades after his death, in 1936 the Carter White Lead Works Company dissolved. Its holdings were distributed to the New Jersey–based National Lead Company, although the Carter brand lived on for a while out of the Chicago plant.[77] Beginning in 1907, shortly before the *Daily Bee* wrote its profile on Carter, the National Lead Company had launched a new product line—Dutch Boy white lead paint.[78] The long-forgotten white lead works in Omaha with a paint production plant, one that replaced the "Dutch process," served as a precursor to one of the most recognizable names in the industry.

Beyond Levi Carter's facility in East Omaha, the city that would one day bear his name had little use for the glowing adjectives bestowed on him. The community, in its earliest days, became a gritty border town at night, with many of the business owners priding themselves on vice rather than the widely reported virtue of Carter Lake's namesake. As it was home to saloons, gambling houses and brothels in its earliest days, enterprising merchants chose to capitalize on the community's murky legal status. The

hardy residents battled flooding and law enforcement in what historians have since described as a "pretty lawless and joyless area."[79]

Despite that, Omaha police presence was briefly pulled from Cut-Off Island in 1891 over concerns about jurisdiction—which were resolved later that year by the U.S. Supreme Court—and effectiveness. Newspapers noted the bars on the island refused to pay city taxes, and the lack of arrests of owners who defied city ordinances left authorities "somewhat disgusted with their attempts to make Cut Off Island a law-abiding community."[80] (The greatest irony of this situation is that the U.S. Supreme Court would soon rule Omaha never held any jurisdiction over the territory at any point before, during or after the flood.)

The name of "Cut-Off Island," though it seemed to be a fitting moniker for the small community in that day and age, was unpopular among those who hoped to polish this gem for tourism. While briefly summarizing Carter Lake's colorful history in 1997, the *Omaha World-Herald* reported that a city park board member had advocated for a name change, believing the term described a "no man's land, prize fights or an amputated leg."[81]

A couple years after his death from bronchitis and acute Bright's disease in 1903, a sizable chunk of the fortune Carter left to his widow, estimated to be between $500,000 and $1 million, would go toward a park along the shore of what had been known for a generation as Cut-Off Lake.[82] Rather than viewing the land as an orphaned segment of floodplain along the former path of the Missouri River, the industrialist's widow, Selina Carter, envisioned the crown jewel of the Omaha parks system.

After her husband's death, she married Edward J. Cornish, who was elected president of the board. He was appointed president of the company following Carter's death and also served as chair for the Omaha Parks Board. Cornish, for whom nearby Cornish Boulevard is named, and his wife donated a significant portion of the late Carter's land holdings to become the park, along with a sizable gift for improvements, which would include a boathouse and boardwalk.[83]

At 303 acres, it would account for nearly a third of the city's total park land, split among its thirteen parks, in 1909. With the park's water "clean and sweet, fed by springs connected with the Missouri [R]iver," the planners had designs for a park that "will undoubtedly be listed among the pictorial panoramas lying outdoors in the United States that are worth traveling to see and enjoy.[84]

That goal undoubtedly would have pleased Levi Carter, whose widow said she was inspired to make her gift to the city because "her husband had

The southwest shore of Carter Lake, where the original park named after Levi Carter once sat, 1908. *From the* Omaha Daily Bee.

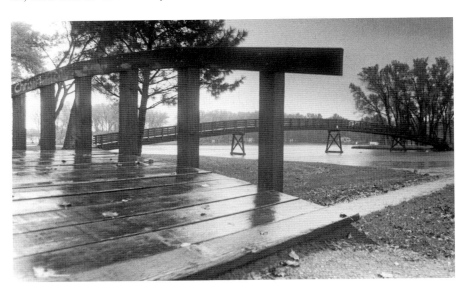

This undated file photo shows footbridges spanning the waters of Carter Lake between Levi Carter Park and Kiwanis Park. *Council Bluffs Public Library.*

enjoyed the lake on his daily drive to work in east Omaha."[85] Now, drivers heading along the lake's north shore use Levi Carter Drive, which runs very near a park overseeing a recreational lake—both of which also bear the name of "the first to see its desirability for park and boulevard purposes."[86] And from this park on the lake's east shore, the Iowa community bearing the Nebraska businessman's name is easily visible.

Shortly after Levi Carter Park was officially renamed in 1908, the *Omaha Daily Bee*'s profile of its namesake told of his love of the lake. He was a

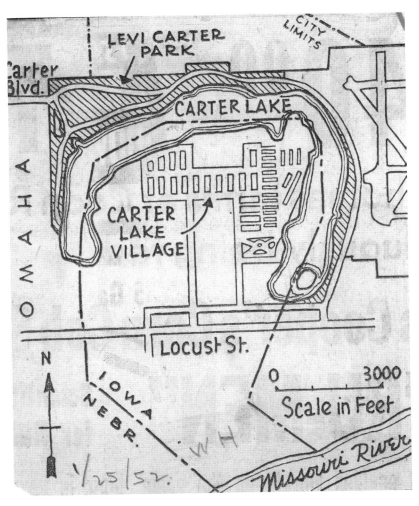

This 1952 map shows Carter Lake, bounded by Levi Carter Park on the north and east sides, and Eppley Airfield. *From the* Omaha World-Herald.

frequent visitor to see the boys who fished along its shores. Following his wife's donation, Carter, in death, was able to give unto generations more who enjoyed the oasis so near the city into eternity. "If those whose bodies have died are conscious of mundane affairs," the *Daily Bee* wrote, "they who know the soul of Levi Carter know that his richest reward will be to see men and women and children enjoying themselves in Levi Carter park on the shores of Salina [*sic*] sea."[87]

# SECESSION FROM COUNCIL BLUFFS, SPURNING FROM OMAHA

Nebraska developers eager to build on what they thought was land within the Cornhusker State in the late 1880s began constructing homes and neighborhoods for workers in the nearby factories in North Omaha and East Omaha. While North Omaha remains a universally understood term for portions of the largely African American area to the north and, to a lesser extent, west of downtown Omaha, East Omaha lacks a clear identity in the twenty-first century.

To be clear, the terms "East Omaha" and "Carter Lake" were used nearly interchangeably until the late 1920s. Many newspaper articles from the time of Carter Lake's secession refer to the small Iowa community as "East Omaha." However, the two locales were neighboring communities in neighboring states; both have always been distinct municipal entities and geographic areas.

Originally platted as an independent city in 1854, East Omaha was annexed three years later by its much larger neighbor to the west. Local historian Adam Fletcher Sasse says the region is bounded to "south of the present-day Eppley Airport, west of Abbott Drive and north of the river."[88] Today, only a few streets on Omaha's street grid carry the designation of "East." Generally speaking, the city's numbered streets become larger numbers from east to west, beginning with South First Street near the Missouri River's easternmost point in a South Omaha neighborhood.

One of the most major streets denoted with East is Fort Street, which runs east–west a couple blocks north of Carter Lake's northern shore. The name changes to East Fort Street when the grid abruptly jumps from North Second Street to North Eighth Street East due north of Carter Lake. (The Carter Lake grid is about two blocks off the East Omaha grid, as North Tenth Street in Carter Lake corresponds roughly to North Eighth Street East in Omaha.) Notable places in East Omaha beyond Eppley Airfield are farther to the east, much nearer the river, and include the Open Door Mission charity on North Twenty-Third Street East and the Omaha Correctional Center—which was vehemently opposed by Carter Lake residents—on Avenue J East.

But beyond this handful of streets, almost no vestiges of the East Omaha originally sought by developers, a region that included present-day Carter Lake, can be found today near the Iowa community. Floods, nonprofits and Omaha officials demolished what was once a fairly autonomous section of Omaha; its old Pershing school and remaining houses are little more than memories for older residents. As Fletcher Sasse said on his blog: "Barely anyone knows about the neighborhood that used to be there, and there's no reminders of what used to be. This is Omaha history."[89]

Originally intended for use on the Burlington Railroad after being purchased by the East Omaha Land Company, the level lowlands northeast of downtown Omaha were instead converted into plans for "the creation of a manufacturing city."[90] Incorporated in 1887, the new company was headed by four men, two of whom would later have streets in North Omaha bear their last names. Another was George Holdrege, whose name is forever memorialized by the south-central Nebraska town of Holdrege.

Within five years of seemingly around-the-clock work and a $300,000 price tag, a small community known broadly as East Omaha had been hewn out of the two thousand and change acres of wilderness. Gone were the brush, swamp and forest, replaced by seventy-seven miles of "cleared and turnpiked" roads.[91] The East Omaha Land Company leased the first thirty-six homes to occupants, providing them city water and trash pickup. The first schoolhouse opened there in 1892, serving thirty-four students.

Also in 1892, a rail line that served the major industrial operations connected with the main Burlington track, while a bridge that connected Carter Lake and East Omaha to Council Bluffs—which still stands but has long since been retired from everyday use—was completed a few years later. A new electric streetcar, too, had been linked with the Omaha system.[92] The Omaha and Council Bluffs Street Railway Company purchased some land

along the beachfront from Ed Creighton—a prominent businessman who founded both Creighton University just north of downtown Omaha and a town in northeast Nebraska bearing his last name—in the 1880s. In turn, that property became the first public beach on Cut-Off Lake before the company later began selling lots on other land it purchased from Creighton. A benefit for the future city was that the land ownership allowed Carter Lake to become well connected to many Omaha neighborhoods through the trolley system.[93]

Despite the organizers' efforts, "East Omaha did not become a second South Omaha as an industrial center" as planned; the only industrial facility of note was Levi Carter's lead works.[94] The boom later turned bust, and the East Omaha Land Company declared bankruptcy in 1902. Much of the lands were later used for dairy operations, primarily by Danish immigrants, most of whom have long since left the area. Squatters, too, became a problem after the company's assets went into receivership, Simpson wrote, and "cloudy land titles" were a common occurrence for many years in the town's early days, even though the squatters lost nearly every court battle. Separated by both city lines and state boundaries, Carter Lake and East Omaha grew apart and faced very different fates despite their proximity to one another.

However, despite being trapped between two large cities, citizens of Carter Lake were isolated on an island. Council Bluffs, which exercised jurisdiction over the area, extended "few if any municipal services" or the necessary utilities into town during the 1920s despite Carter Lake residents paying the same taxes as those who lived in the city east of the river.[95] Things considered commonplace for city residents at the time—police and fire protection, paved streets and running water—were simply not being provided to some portions of the exclave. The East Omaha area, meanwhile, received these services from Omaha. The *Omaha Daily Bee* reported residents went as far as paying out of their own pockets to pour gravel to cover the community's streets, "yet delegation after delegation has gone to Council Bluffs for relief, only to be turned down."[96]

Carter Lake residents became incensed with how their area was exploited for its tax dollars, paying the same amount as a Council Bluffs resident yet without the comforts of paved streets, running water and electricity. The man who would become Carter Lake's first city attorney, DeVere Watson, a Council Bluffs lawyer who also served sixteen years in the Iowa Senate, once reportedly quipped that Carter Lake was "cut off for all purposes except that of collecting taxes."

From that grew the rumblings of Carter Lake's secession from Iowa. By 1925, the Carter Lake area had grown to 350 residents, many of whom were leading Omaha businessmen and their families who sought to build luxury homes on or near the lakeshore in the Carter Lake Club. Still a segment of Council Bluffs' Sixth Ward, the community paid $33,000 in property taxes to Pottawattamie County, yet residents reported receiving only $6,000 in services from the city or county. In fact, as William Fraser, told the Iowa-Nebraska Boundary Commission in 1926, most services received—including water, mail, streetlights and telephone—were purchased from Omaha in a situation that, the *Omaha World-Herald* remarked, "smacked of something akin to the Boston Tea Party."[97]

"The land in question does not in any way touch that of Iowa. It is only connected by air. It joins onto Iowa and will ultimately become a part of the city," Fraser argued to the commission. "We want some consideration of where our money is going. It can't be a case of taxation without representation."[98]

On that point, the attorney had a strong case. The only physical connection was across a river; residents would have had a journey of at least seven or eight miles through Omaha to use the lone toll bridge that connected the cities. Furthermore, while residents had no high school of their own, they were required to "pay school taxes and are forced to send their children to Omaha high schools and must pay tuition" there, too.[99] Despite this, the *Omaha Daily Bee* reported that "residents of the district have never had a representative on the Council Bluffs city council or school board, and that many residents did not even know who was mayor of the city."[100]

Omaha had long since pulled its police presence from the area, and its parent city, Council Bluffs, stationed no police or fire units in Carter Lake. Instead, those responding to emergency calls "had to travel over the then-Douglas Street toll bridge, traverse a large portion of Omaha's central business district, pass along more than two miles of heavily traveled Sixteenth Street, and cross the Locust Street viaduct before it could reach the community"—a distance of more than seven miles from downtown Council Bluffs.[101] If the fire or police call was in the Carter Lake Club area, first responders would have needed to travel nearly eight miles. This created long response times, which in turn led to astronomical insurance rates for residents.

Late in 1925, the first sparks of secession flared up but quickly disappeared. Trustees of the East Omaha Land Company hired an attorney and floated the idea of leaving Council Bluffs to its city council. Though the council laughed off a proposal they considered "preposterous," the city's mayor,

Jack Harding, "urged them not to treat the matter so lightly."[102] Businessmen from Council Bluffs also fought back, arguing that the city had, in fact, spent tens of thousands of dollars to build a school, install fire hydrants and water mains and outfit for the city "special officers and a detail of motorcycle pillbox officers, who keep in constant touch with the Council Bluffs station by telephone."[103] Though the wheels fell off this particular attempt, residents' desire for a greater say in their own governance only continued to grow.

At first glance, it may appear that the body that provided the impetus for Carter Lake's ultimate secession—the parent-teacher association at the community's school—was an odd one. But it was truly the only elected board with any authority on which Carter Lake residents had any representation. Simpson noted the PTA was "also the only instrument that could reach the majority of the residents" of Carter Lake.[104] Furthermore, the school building, which residents believed deserved funding from the city for repairs, was one of many tangible symbols of the deaf ear residents felt their city leaders in Council Bluffs had turned toward them. The secretary of the Council Bluffs School Board advocated cutting Carter Lake loose, arguing that "it would be advantageous to Council Bluffs to have East Omaha taken over by Nebraska because of the expense to Council Bluffs."[105]

A relatively new Carter Lake resident, Helen Aulmann, had moved into the Neptune Place neighborhood with her family in the early to mid-1920s. In short order, she became president of the PTA. From that position, she called a town hall meeting at Carter Lake's Courtland School in 1926 that had an agenda decidedly different from the PTA's usual aims—to discuss the idea of seceding from Council Bluffs, even inviting Mayor Harding of Council Bluffs and several other officials from the city. The *Omaha World-Herald* described the meeting as "a most enjoyable affair" that Aulmann said was "to hear the two views of the matter so that the residents might be better qualified to make their decision."[106]

Throughout the meeting, both leaders within the renegade Carter Lake district and its parent city freely admitted that secession from Council Bluffs would be a simple matter to do legally, but the dividing up of debt and liabilities could be somewhat problematic, as both Fraser and Harding provided different figures. The geography and growth of Carter Lake, many admitted, made things difficult for both sides, so much so that even the Council Bluffs mayor said he understood the reasons behind the secession movement and promised not to fight against it. As Harding told the assembled crowd: "If you people, with full understanding, want to quit Council Bluffs, I assure you there will be no opposition."[107]

Ultimately, the proposal passed, and the city's secession attempt moved forward. A twenty-seven-month legal saga, one that reached the Iowa Supreme Court after Council Bluffs appealed the original victory for eighty-one Carter Lake residents, succeeded in September 1928. The state's highest court affirmed that it had the right to "divorce" Council Bluffs.[108] Subsequent court rulings issued on June 19, 1929, regarding assets and liabilities officially removed the Carter Lake area from Council Bluffs' jurisdiction, resulting in a net loss of between $6,000 and $7,000 in general city tax "for Council Bluffs."[109]

With their community now considered a part of unincorporated Pottawattamie County, secessionists in Carter Lake wanted to be absorbed by Omaha and into Nebraska. However, this plan had two hurdles to overcome—one external, one internal. Within Carter Lake, one faction, a combination of farmers and residents along Locust Street, believed the community would be better served by remaining unincorporated than by becoming a city. Though they enjoyed being free from Council Bluffs, they expressed trepidation about the fear of heavy taxes if Carter Lake incorporated.

The primary obstacle came from Omaha, the city into which the secessionists hoped to be absorbed. Fraser told the *Omaha World-Herald* in 1960 that he obtained the signature of "every citizen in the Carter Lake area" in 1928, and all "desired the area to become part of Nebraska."[110] The Cornhusker State, residents noted, provided most of the jobs, water service, access to a high school and the only routes in and out of town—and to Council Bluffs, where its courthouse, tax revenue and law enforcement were based.

Just as Council Bluffs had ignored pleas to provide utilities and city services to Carter Lake, Omaha officials, too, "refused to consider the offer" and failed to act or extend anything beyond the water it was already providing the town.[111] The Iowa residents would not soon forget that slight when Nebraska later decided that Carter Lake should become part of its state, a legal tug of war that stretched on for seven more decades.

"Nebraska didn't want anything to do with us years ago when we were poor," town clerk Gladys Barton told the *Daily Nonpareil* in 1960. "Now that we've got new homes, a good school, and other new buildings and taxable property, they have suddenly become very interested in us."[112]

By this point, Carter Lake residents were firmly loyal to Iowa—and had zero interest in switching sides. The only logical reaction, they determined, was to take matters into their own hands.

# LED BY A COLORFUL MAYOR, CARTER LAKE FIGHTS ON AS AN INDEPENDENT CITY

D ivorced from one city and spurned by another, those who spearheaded Carter Lake's secession instead decided on another course of action: founding their own city. And on June 2, 1930, by a vote of 171 to 124, voters approved Carter Lake's incorporation as the newest municipality in the state of Iowa, a result buried in a matter-of-fact report on page seven of the *Daily Nonpareil* the next day.[113] Gone was the last official tie to the name of the city it unsuccessfully sought to join, the East Omaha Land Company that developed the community. Carter Lake's ultimate statehood, however, would not be put to bed that easily.

Now, with the ability to levy bonds and have its own elected officials dictate how it chose to spend its own money, the faction that sought independence for Carter Lake had now ensured the infant city's residents would no longer have the "taxation without representation" about which Fraser had complained to commissions in both Iowa and Nebraska. The roughly $7,000 in tax receipts from the area that would have been going to Council Bluffs was now fully Carter Lake's, and the new city held its tax levy flat.[114] The election gave birth to the geographical oddity of an Iowa city now accessible only by Nebraska roads—even though its first major public works project as an independent city was to pave North Thirteenth Street and Locust Street, its link to Omaha.

But Carter Lake had to elect government officials and have the results verified by a judge before it officially became certified as an independent

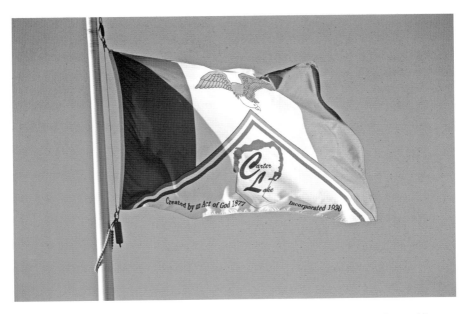

Carter Lake's official flag has a map of the town and lake above the words: "Created by an Act of God in 1877. Incorporated 1930." *Author photo.*

city. On July 5, 1930, Carter Lake officially became Iowa's newest city. Of the 962 cities in the state to have ever officially been incorporated, data from the Iowa Secretary of State's office indicate Carter Lake is the forty-seventh-youngest municipality in Iowa.[115] However, the seemingly simple election wasn't guaranteed to run smoothly. An attorney representing the ticket that would be defeated in Carter Lake's first official vote insinuated at a meeting the night before ballots were cast that five residents of the new town had also voted in Omaha's most recent election—making it illegal for them to vote to fill Carter Lake's offices. His remarks made the "tense feeling burst its bound, and riot reigned" just hours before voters filled its municipal offices for the first time.[116]

After a strong voter turnout—still a hallmark for the city today—residents of the new community voted Al E. Schneider as its first mayor. He ran on a campaign slogan of "Get Carter Lake village out of the mud as soon as possible" and promised to pave both Locust and North Ninth, which ran north to the Carter Lake Club, at the first possible chance.[117] But like so many things involving Carter Lake, even this act as an incorporated city could not come without a speed bump. As always seemed to be the case, issues with its border with Nebraska and allegations of broken promises by one of its larger neighbors again hovered over the work.

Carter Lake eventually paved both streets in addition to Thirteenth Street at a cost of roughly $80,000.[118] Newly paved Locust Street appeared on the surface to be a win-win. Residents of the new municipality could much more easily access Omaha on a paved road, while Omaha residents would benefit by gaining a more direct path through Carter Lake to the municipal airport that has now become Eppley Airfield. However, the state line again led to an impasse: Omaha's paved section of Locust Street ended roughly one thousand feet shy of the border. In exchange for providing the concrete, Carter Lake officials reportedly asked Omaha for a police presence. While the infant village carried through on its end of the bargain, residents of the community insisted Omaha had failed to hold up the terms to which it had agreed—a familiar refrain in the history of the relationship between Carter Lake and the principal cities in the metropolitan area.

Yet no insult made residents and officials alike as incredulous as when Iowa officials told Carter Lake in 1936 that they had no record of the town's existence. Leaders of the young city sought assistance from the Works Progress Administration to help construct a city utility building. Their effort was denied on the grounds that the state "had no evidence that the town of Carter Lake exists within the boundary of the State of Iowa," a claim that was seconded by the same Iowa Secretary of State's Office that had incorporated it six years prior.[119] For many years to come, the city was jokingly dubbed the "forgotten town."[120] The WPA later relented, upon notice that Carter Lake did, in fact, exist—even if it was west of the Missouri River—and the leader of that effort would become the face of the community for many years to come.

In 1934, a young man in his early thirties who served on the Carter Lake City Council successfully ran for mayor. Wilson Mabrey, who moved to town in 1926 and lived in the blue-collar area on the western portion of Locust Street, became the city's third mayor. Not a native Iowan, Mabrey came to the area in 1920 as part of a Western Union wire gang, later taking a job with the U.S. Army Corps of Engineers. However, he was forced to resign to take the mayorship, and he later opened a service station at the corner of North Thirteenth and Locust Streets.[121] Mabrey's introduction to politics had been the seat he won on the small town's inaugural council on the "progressive" ticket organized by those who crusaded for the incorporation of the town, finishing second in an eight-person race for five at-large seats.[122]

Despite his routine landslide victories and unopposed elections (only a few candidates ran against him, and he won every contested election by at least a two-to-one margin), Mabrey was a polarizing figure.[123] He was well regarded by the so-called swamp rats, the derogatory term well-to-do Carter Lake

residents used to describe Mabrey and the people from the neighborhood on the city's southern and western edges where he first lived, far from the higher-end homes on the lakeshore. That dichotomy best represented Mabrey's mayorship, characterized by rapid growth, silent endorsement of the barely underground gambling and drinking establishments and dogged determination to keep Carter Lake in Iowa:

> *A cheap crook, a man who gets things done, a smart politician who is too clever for those "guys" in Omaha, best man we could ever put in office, a small town boss, a little dictator, and a nice young man we thought would make a nice councilman but turned out a real stinker.*[124]

Anecdotes abound of Mabrey's fervent dedication to his adopted hometown, though they pale in comparison to his efforts to give Carter

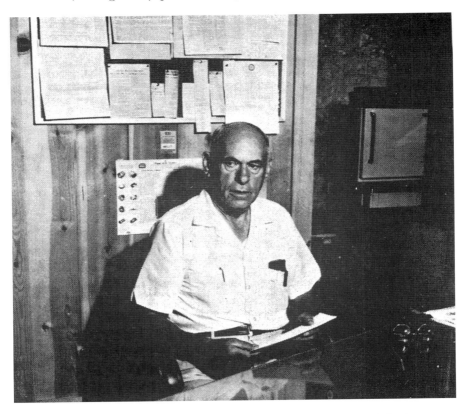

"I'll fight for our people," says Carter Lake mayor Wilson Mabrey as he looks back over a career spanning more than three decades in office, 1965. *From the* Omaha Sun.

Lake its rightful share of the gasoline tax, which funds road maintenance in Iowa. Although the city had been paying into the pool, it received nothing in return. Mabrey used the city's general fund to cover the costs for paving and maintenance, although it quickly ran low. In turn, he "donned his overalls, mounted the village tractor and maintained the roads himself."[125] Residents recalled that the gas reportedly came from his own filling station.

Amazingly, the pro bono work the mayor did keeping up his city's streets was nothing compared to his efforts to ensure the city received its deserved slice of the pie for road maintenance. Mabrey spent thirty straight days in Des Moines on his one-man crusade as the "lowest-paid lobbyist" in the capitol, paying his own way while simultaneously foregoing the $1 salary he'd have earned had he attended city council meetings.[126] He pushed for fairness, advocating that even the seven-year-old city should receive the same aid, which would save its taxpayers at least $1,500 a year, as any other Iowa community. When the bill was finally signed into law, Mabrey acknowledged he had been nothing more than "a greenhorn" in state government. He did, however, walk away from Des Moines having learned about the machinations of the Iowa General Assembly. Teaching moments from his efforts were a two-way street, as legislators noted they "learned a lesson in perseverance from him."[127]

For much of his mayorship, Mabrey was a familiar sight to see supervising or working with city maintenance crews—even after his efforts won the city its rightful gas tax revenue. He did not stop, either, after being elected to a two-year term as president of the Iowa League of Municipalities in 1942.[128] At one point, he told the *Des Moines Register* he carried a badge, a gun and handcuffs as head of the city's police department during one of its many internal skirmishes.[129] Much like when he fought for the city's share of the gas tax, he was seldom far from the front lines of action in Carter Lake. During the flood of 1943, Mabrey helped with efforts to fill sandbags and set up temporary dikes as the Missouri River rose, eventually causing him to lead the evacuation before eight feet of water covered his town. Once the water began to recede, he put on his chest waders and initiated a salvage operation for the waterlogged community.

In 1957, the community's mouthpiece began losing his ability to speak. Mabrey's condition baffled local doctors, and experts at the Mayo Clinic later diagnosed him with a "nerve under pressure in his skull." Although later he regained his voice, the illness left Mabrey with a speech impediment for the remainder of his life.

Though he spoke of the city's unity when defending Carter Lake from Nebraska's advances, Mabrey was a lightning rod for controversy to

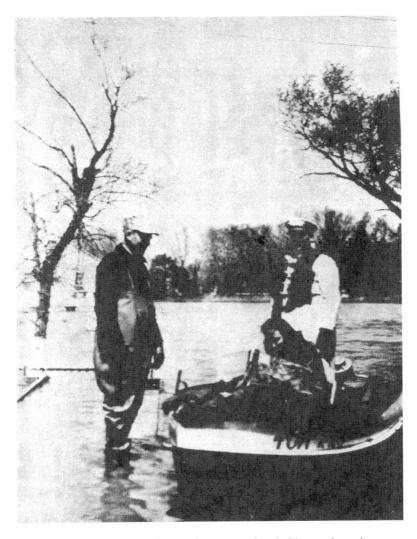

Mayor Wilson Mabrey (*left*) directs salvage operations in his waterlogged community as the river begins to drop, 1965. *From the* Omaha Sun.

some residents. Just one day before the 1965 mayoral election, he was arrested and charged with permitting private use of public property amid allegations that he allowed contractor Gerald Waltrip to use a city road grader for nearly four months.[130] A furious Mabrey chalked the move up as "the dirtiest political trick I ever saw," but he promised the *Daily Nonpareil* that he would beat his opponent.

The mayor won the election—as he always did—but celebrated his victory that year while out on bond.[131] He was also later found innocent of the charge, as a judge ruled "the machinery in question was surplus equipment."[132] Waltrip later returned the grader, which Mabrey said was being sold by the city, with a $400 check. (He was, however, convicted in 1953 of running a bingo parlor after testing the waters of an Iowa Supreme Court ruling with which he disagreed regarding the outlawing of cash games of bingo.)[133]

Mabrey never lost an election in Carter Lake at any point during his political career of more than three decades, although two efforts in the 1950s to seek higher office in the legislature were unsuccessful. Even after he told the *Daily Nonpareil* in 1965 that he would step down when his term ended in 1969, he came back for one more campaign, which, of course, he won handily.

Gertrude Livingston, his longtime assistant city clerk, said the mayor was known for his generosity in throwing children's holiday parties and giving less fortunate families meals for Thanksgiving.[134] His fifth wife, Peggy, was among the city workers who delivered the gifts and meals to residents, although she wished her husband had been able to hear the thanks he received. "I got to hear 'Thank Mr. Mabrey for me,' or 'God bless Mr. Mabrey,'" she said. "It should have been him hearing that." Land in Carter Lake he purchased to donate to returning soldiers to build homes would also, at one point, become the residence for his stepson.[135] The *Des Moines Register* noted that Mabrey, who lived off the lease of his gas station and revenue made from selling property he'd purchased throughout town, sold his home and lived as a renter for most of later years in office, the result of how he "ruled with a wink at sin, a warm heart for the needy and to the detriment of his own personal and financial conditions."[136]

From the founding of the town in 1930, Mabrey was involved in its governance for the first forty-three years of its existence—finally retiring in 1973, with his final thirty-nine years of public service as Carter Lake's mayor. Gerald Waltrip, then a city councilman, and the man to whom Mabrey had lent the road grader, won the election to replace Mabrey at the helm of the city in November 1973—despite Mabrey's endorsement of his challenger. While Waltrip has not for served thirty-eight years like his predecessor, the time between his first and most recent terms actually stretch over a longer period of time. He's now in his fourth elected term for his third nonconsecutive stint in the office, having won election over incumbent Russ Kramer in 2013. Waltrip also served as mayor from 1973 to 1977 and 1985 to 1993.[137]

On Mabrey's watch, the population of Carter Lake grew from an estimated seven hundred people at his election to more than three thousand when his final

Carter Lake Planning Board chairman Roland Lewis (*standing*) is pictured here speaking with (*left to right*): city attorney John Churchman; Councilmen Russ Kramer and John Ferryman; Mayor Gerald Waltrip; city clerk Doreen Mowery; and council members Wanda Rosenbaugh, Paul Christensen and Don Ortiz. *From the* Daily Nonpareil.

term ended. The city remained in Iowa despite myriad efforts by Nebraska to claim it. More importantly to Mabrey, the community that had few paved streets and was only beginning to install its own utilities when he took office had blossomed into a successful small town with the self-rule it had craved for so long. As he told the *Des Moines Register* shortly before his final term in office expired: "I think I've been good for Carter Lake, at least that's what people tell me. I helped bring in the new sewer system, helped get new houses built and pushed for our share of road money. I've done my best to make it a better place to live, and that's what I said I was going to do when I ran in 1934."[138]

Just four years after leaving office, Mabrey died in 1977 at the age of seventy-five. Although he had retired to West Palm Beach, Florida, when his last term ended, he made one final appearance in the city he had presided over for more than half of his life—his funeral, which was held at Carter Lake Presbyterian Church.[139] His final resting place, however, is not within the city; in yet another of the oddities that define it, Carter Lake has no cemetery within its borders. Mabrey is instead buried in Forest Lawn Cemetery in Omaha, the city to whom he had been a constant thorn in the side for nearly four decades. Fittingly, a small street that leads to city hall is known as Mabrey Lane.

Despite the differing opinions about Mabrey, everyone could agree that he was a character. The transplant with a sixth-grade education had been divorced

Carter Lake's modern city hall sits at the corner of Locust Street and Mabrey Lane, named after the longtime mayor. *Author photo.*

four times, convicted on one count and found innocent of another while in office and carried a speech impediment around for the last half of elected service in "what might be called the little kingdom of Carter Lake."[140] Peggy Mabrey, his fifth and final wife, noted in 1994 why her late husband divorced and remarried so many times: his first true love was the city he served. "That's why everyone liked Wilson. He worked for the city. That's why he had so many wives. He cared for the city more than his mates. Carter Lake was his baby."[141]

Yet all accounts also indicate that Mabrey was not a man who cared much for external opinions—except those of his constituents.

> *To the people of the little town of Carter Lake, Ia., he's their fighting mayor. To the city of Omaha and the Nebraska legislature, he's an irksome roadblock. To the Iowa legislature, he's been a burr under the saddle since 1934. To all of them, he's known officially as Wilson E. Mabrey, mayor of Carter Lake....Whether he be a fighter, a thorn or just a pain in the side, the Mayor of Carter Lake has left no doubt in any one's mind where his town stands.*[142]

Of all the adjectives and nouns used to describe Mabrey, though, one resident most accurately and succinctly captured the feeling of his constituency: "Why, he's literally been Carter Lake."[143]

# ENTERTAINMENT STRADDLES STATE LINES

## *Amusement Park by Day, Illicit by Night*

Throughout its existence, Carter Lake has been a recreational area—an escape capable of providing a good time under the shadows of the Omaha skyline. Two entertainment interests capitalized on the 1877 flood in attempts to draw people to the Carter Lake shoreline: family amusement parks along the beach and illicit underground gambling operations attracted to the gray area of confusing legal jurisdictions. Carter Lake was long a playground for Omaha residents, regardless of the season.

On the northern tip of Carter Lake was Courtland Beach, a swimming hole turned into an amusement park, highlighted by one of the first roller coasters in the Midwest and the first in the immediate region in 1895.[144] Another attraction, Carter Lake's most popular resort, which opened sometime in the early 1890s (different sources range from 1890 to 1893), was linked to Omaha and South Omaha—then an independent city before its annexation into Omaha—through the streetcar system.[145] The resort included a merry-go-round and shows ranging from parachutists jumping from hot-air balloons to mind readers.

During its short run, it was a recreation hot spot for Omahans that pulled out all the stops, such as this recollection of the sights and sounds on July 4, 1904:

> *In the afternoon and evening Nordin's 40-piece band and Becker's Lady Orchestra were heard. A balloon ascended. Oscar and Siri Nordin dove 120*

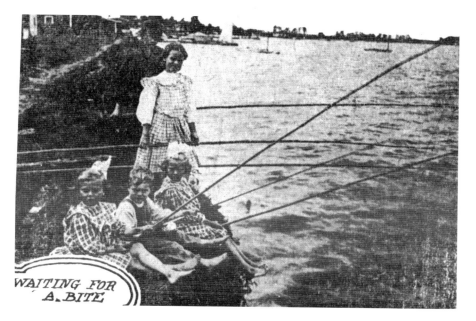

A group of children fishing off the bank of Carter Lake, 1911. *From the* Omaha Daily Bee.

*feet into a tank of water. Prof. Richey, the Iron-Jawed Man, swung by his teeth from a trapeze. Trixie, Smartest Horse on Earth, did her tricks. The New York All-Star Vaudeville Co. vied with the Old Plantation Quarter. The Thurston Rifles put on precision drills and a sham battle with Gatling guns. You would visit the Gypsy Fortune Tellers, or Zoo.*[146]

In the summer, the oxbow lake was for decades regarded as one of the region's finest swimming holes and water playgrounds. Accordingly, Omaha "residents came in droves, playing on the beach, renting boats and canoes for rowing across the lake, and swimming in the smooth, safe waves lapping across it's [*sic*] surface."[147] The now-defunct *Omaha Daily Bee* expended countless column inches on its society and news pages describing the activities both and in and along the water.

Samplings from just one day of *Daily Bee* clippings included "a couple ostriches" at the zoological garden, a slide, balloon races and a "switchback"—presumably a reference to the first American roller coaster of the same name at Coney Island.[148] Another *Daily Bee* story—this one from April 15, 1920—told of an unseasonably warm spring day that captured the lake's allure. Despite lines so long that it took half an hour to find a parking space, Carter Lake was the place to be that day. With the pop of trapshooting

Fifty-six youths from CCC camps of Nebraska and South Dakota took part in lifesaving exercises on July 8, 1939, at Sand Point beach along Carter Lake. *From the* Omaha World-Herald.

and laying of clay tennis courts on the shore, Omahans flocked to the lake to take dip in what a woman called the "finest water I ever was in."[149]

The Omaha Rod and Gun Club later purchased the amusement park land sometime between 1905 and 1910, holding well-attended hunts for turkeys and other wild game in the area, although the lake's primary activity for the sportsman has historically been fishing. But local historian Adam Fletcher Sasse noted the contribution of the fifteen sportsmen who bought the since-shuttered amusement park may have been the legacy of both development and preservation at the lake:

> *They may have been the most important among the many private clubs along the lake, many of which built bungalows and docks for all kinds of recreation. Along with watercraft and shooting, there was incredible fishing. As early as the 1890s, the State of Nebraska had been stocking the lake, and ornithologists flocked to the lake's shores to watch for the beautiful flocks that swarmed up and down the Missouri River Valley.*[150]

The Carter Lake Club, a collection of homes along a short boulevard that still exists today, was the site of numerous get-togethers. The land the Carter Lake Club occupies was purchased from the Rod and Gun Club. Athletic endeavors on land ranging from baseball to bowling—not to mention sailboat and canoe races on the water—were organized by the area's residents. Even on land, races on the shores of Carter Lake were popular. Before Eddie Rickenbacker became the most decorated fighter pilot in World War I, he averaged nearly ninety-two miles per hour in an automobile race on a long-gone oval track.[151]

The *Daily Bee*'s descriptions of the conditions for anglers in the 1910s were written in the glowing language of a twenty-first-century travel guide. One article detailing the stocking of three thousand game fish narrates how the creatures were "gaily swimming" in the lake after being transported roughly thirty miles from Gretna, Nebraska. "Not a one of the fish but was in the finest condition when the destination was reached," the reporter surmised.[152] Finally, the state's governor, Ashton Shallenberger, "was greatly pleased" with the status of the fish, which he stopped by to see while awaiting a train.

However, Courtland Beach and the other resorts would eventually fade, receding into history under pressure from new outdoor parks. The Fourth

Thomas Jefferson High School junior Joseph Prez (*left*) shows freshman Dalton Axtell how to tie a Palomar knot at Carter Lake on October 10, 2013. *From the* Daily Nonpareil/*Kyle Bruggeman*.

of July extravaganza from 1904, mentioned earlier in this chapter, "made a big splash, but lost money."[153] Some, such as Peony Park and Krug Park in central Omaha live on as names for a grocery store plaza and a bar, respectively. Hanscom Park in South Omaha and Fairmount Park in Council Bluffs—both of which turned their focus to more serene nature settings—are among those that live on to this day. Urban sprawl, increased streetcar access and new offerings at more recently developed sites helped spell the end for Carter Lake's best known amusement park.

One such direct rival, offering watersports, a circus and an amusement park, was Lake Manawa in Council Bluffs, which once boasted a ballroom, a roller coaster, a casino, an amusement park and streetcar access.[154] The body of water, now Lake Manawa State Park, a river-fed lake created by a major Missouri River flood, was once partially in Nebraska but has since become a part of the second-most heavily trafficked state park in Iowa with nearly 866,000 visitors, based on state data from 2011.[155]

As the *Daily Bee* wrote less than a decade after Courtland Beach's establishment, competition for the amusement park's existence, such as the long-since-defunct Lake Manawa amusement park fewer than ten miles away, threatened its success:

> *Mr. Griffiths (park manager) asks the assistance of every public-spirited citizen in and about Omaha and South Omaha to drop for all time "Cut Off lake," and when it is found necessary hereafter to refer to that beautiful body of water to substitute "Lake Courtland," which certainly sounds better and gives to strangers a better impression….The people of Council Bluffs were only too glad to drop "Cut-Off for Manawa."…Mr. Griffiths insists that within two or possibly three months everybody will be saying "Lake Courtland," thus adding dignity to Omaha's only body of water.*[156]

Joel Cornish, a nephew of the Edward Cornish who married Levi Carter's widow, and Wilson Mabrey battled over the use of land in western Carter Lake now occupied by Shoreline Golf Course. The one hundred acres, which abutted the lakefront, had been deeded to use as a park and owned by the Carter Lake Development Society headed by Cornish, an Omaha resident. Mabrey, who vehemently opposed the idea of an amusement park, also accused Cornish of trying to nudge the land toward Nebraska.

The mayor told a joint meeting, "I won't stand for an amusement park like the old midway parks, which are nothing but stationary carnivals. And I'll bring action against any such park that goes in there."[157] Ultimately, the

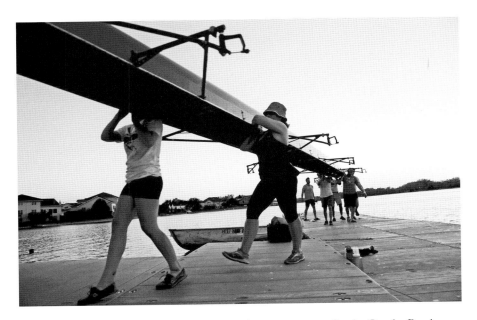

Rowers carry a boat to shore after practice for the masters group for the Omaha Rowing Association at Carter Lake on July 28, 2014. *From the* Omaha World-Herald/*Sarah Hoffman.*

sides reached a short-term deal to make it a recreational park, granting the City of Carter Lake the ability to exercise "legal power to stop anything that is wrong."[158] In its present use as a golf course, which opened in 1990, it meets the desires of both Edward Cornish and Wilson Mabrey, who later specifically pushed for a course there, long after both have passed away.

Subsequent efforts to build a new amusement park on Carter Lake took place on Omaha's shoreline. Adjacent to Carter Lake shortly after World War II, developers built the Carter Lake Pleasure Pier and Kiddieland. The side-by-side amusement parks, which focused on adults and children, respectively, lasted roughly a decade before the land was turned into a marina.[159]

Though remnants of its wooden boardwalk are still occasionally found in the lake, the name of Courtland Beach is lost to all but history; even the origin of the word "Courtland" remains unknown.[160] The city's school building, which carried the Courtland name for decades, is now Carter Lake Elementary School. Changing conditions and tastes led to the park's downfall, as "[s]everal years of flooding near the turn of the century swamped the resort and sent residents scrambling for higher ground."[161] Instead, other recreational bodies of water—including Lake Manawa, as discussed by

*Right*: Assistant golf pro Kip Peterson retrieves a putt on the ninth green at Shoreline Golf Course, 1993. *From the* Daily Nonpareil/*Gary Peterson.*

*Below*: Eric Weber, twenty-one, performs a back roll during his last wakeboarding set of the 2011 season. *From the* Daily Nonpareil/*Cindy Christensen.*

the *Daily Bee*—have now become the area's most popular places for water activities, though Carter Lake remains active for boating and fishing.

But what took control of entertainment when the sun went down on Carter Lake was a less socially acceptable manner of recreation. What began with one man's idea of building a floating bar in the lake to circumvent liquor laws of both states—eventually leading to a lawsuit that ultimately landed in the U.S. Supreme Court and established Carter Lake's position in Iowa—grew into a border town rife with vice: from alcohol, especially after Iowa repealed Prohibition before its western neighbor, to gambling of all sorts.

Not surprisingly, details of this shadowy underworld are, well, shadowy. Little more than rumors and memories tell this portion of Carter Lake's story. Russ Kramer, a former Carter Lake mayor who has studied his adopted hometown's history for decades, said in a 2012 interview with the *Daily Nonpareil* that he had heard of one enterprising gambling hall owner who built his establishment on the state line, represented by a stripe painted down the middle of the room, on the west side of Carter Lake. When Nebraska officials came to raid the building for illegal gambling, spotters would inform the players, who then pushed all the tables to the Iowa side of the room. If Iowa officials made an appearance, the tables would all be on the Nebraska side before they arrived.[162]

A reporter for the *Omaha Daily Bee* detailed his journey into the orphan town in 1889. Just twelve years after the current town site was formed by the river's avulsion, water from the river still lapped at the lake's east end. The article, which also details the hardscrabble existence of the island's earliest days, is one of the best-preserved sources of this environment. One of the stops was a saloon called the "Island House," where the proprietor told the reporter he'd make a killing on Sundays, a day when Omahans were barred from buying alcohol within their own city. He capitalized on the murkiness surrounding the state lines. Within a few hundred feet, the reporter noted six to twelve beer kegs piled outside a pair of nearby saloons, commenting on their status of as "relics of the past Sunday's debauch." Besides a dairy operation and laundry business, these saloons "were the only places where there were any evidence of business."

The journalist documented the following brief exchange with the owner, a young German immigrant, while surveying the city.

*"Is this island in Iowa or Nebraska?"*

*"It's in Iowa. You bet it's in Iowa, if it wasn't you know, we couldn't keep open Sundays," said the voluble young fellow. "You see,*

*they try to make out we are in Nebraska and send cops out here on Sundays to make us shut up, but we don't do it. We give 'em the laugh because we're in Iowa."*

*"I suppose you do the bulk of your business on Sunday, don't you?"*

*"Oh, yes. We don't do anything on during the week scarcely. But, on Sundays, it's lively, I tell you. Oh, we have faro* [the most popular betting card game of the era], *roulette, hazard and all those games running. The island is crowded with people from Omaha."*

*"All men?"*

*"No, there's lots of women. I'm going to make a fourteen-room house out of this so the gentlemen and their lady friends can be private."*[163]

The immigrant's dream to profit from the vices so closely guarded by the people of that time period was just one such story of the city's appeal. Another historical account claimed Carter Lake had "seventeen bars and houses of prostitution within a four-block area," though many of the buildings were reportedly destroyed by a fire years later.[164] By capitalizing on such an unclear legal status for so many years—or silent approval from city hall, depending on the source—such operations flourished without the hindrance of established laws in Omaha or Council Bluffs.

For instance, when Iowa in 1933 legalized the sale of beer containing 3.2 percent alcohol following the end of Prohibition, all sixteen Carter Lake applicants were granted the licenses needed to sell liquor on the doorstep of Omaha, which was still dry. One of the successful applicants was Luke Heeney, Carter Lake's second mayor, who served from 1932 to 1934. He told the council of plans to renovate Lakeview Park and make it the "biggest and most lavish dispensary in the village," with estimates the facility could sell between seven and eight hundred cases of beer per day.[165]

With that, Herman Aulmann told the *Des Moines Register*, Carter Lake received unsavory crowds from Omaha that would come to linger after the sun went down: "Beer…was on sale legally in Carter Lake but not in Omaha. With that condition, the wrong kind of element poured in here and we've had some of it with us ever since."[166]

Another example came when the Nebraska legislature outlawed gambling within the state in 1889—a statute that Omaha's mayor announced the city would begin enforcing on July 2 of that year. The threat was not an idle one, and the established hot spots were found "completely deserted and solidly bolted" the next morning, a day the *New York Times* reported was the "first in the history of the city there has not been an open gambling house."[167]

But in Omaha, a city that boasted more illicit gambling per capita than any other city in the United States in the early to mid-twentieth century,[168] the persistent bookies and gambling hall operators would not be stopped so easily. Though the heyday of crime bosses such as Tom Dennison, a man "with ties to the vast Capone machine" who controlled Omaha City Hall for more than a quarter century in the early 1900s, was long gone by the 1980s, Omaha was a hub for underground gambling nearly one hundred years.[169] As the *New York Times* noted in 1889, "The old timers who have been here many years have declared they will not be driven out. Quietly the proprietors of well established houses are arranging to fit up rooms and conduct business on the sly."[170]

And Omaha's small Iowa neighbor was no different, ready to capitalize on the larger city's love of wagering. The odd geography of Carter Lake played to the advantage of the man who wanted to conduct such business in the shadows, as "a measure of benign neglect was just fine for the hoodlums and gamblers who found a haven here, beyond the reach of Nebraska laws and out of the way for most Iowa officers."[171]

At the center of Carter Lake's notoriety was the ritzy Chez Paree casino nightclub, which brought the glamour of gambling to Omaha's doorstep. Histories describe it as one of the largest and most active casinos of the time between Chicago and Reno, "the dice-rattling hotspot of the 30s and 40s" where you "bet on any horse race in the United States" and "could listen to Sophie Tucker, have the best prime rib in town and enjoy a gambling raid or two."[172] Its renown—and proximity to Omaha—angered then-mayor Dan Butler, who advocated for more raids and unsuccessfully "tried to pressure Iowa officials to crack down."[173] The state line, once again, thwarted several attempts to end the most famous gambling hall for hundreds of miles around.

The swanky facility operated with the tacit endorsement of Mabrey, who said it wasn't his responsibility to shut it down. "We never had any complaints about the gambling," Mabrey told the *Omaha Sun*. "Enforcing gambling laws was the state and county's job. We left them alone, and they left us alone."[174] More recent reports indicated that police were encouraged to avoid the gambling hall as its renown grew. In the perfect embodiment of the outward condescension but behind-the-scenes approval so many Omahans and Nebraskans had about Carter Lake, Mabrey said he had seen Omaha mayors, a Nebraska governor and a Nebraska attorney general—all of whom would have publicly scoffed at the Chez Paree—at that very facility. "And," Mabrey said, "I was proud to meet them there."[175]

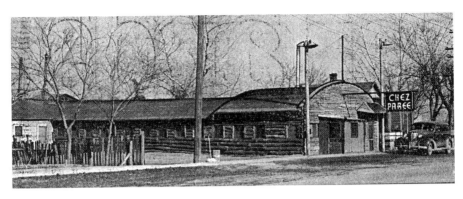

Carter Lake's Chez Paree, as seen in 1939. A fire destroyed the building in 1942, but it carried on in another location through the 1960s. *From the* Omaha World-Herald.

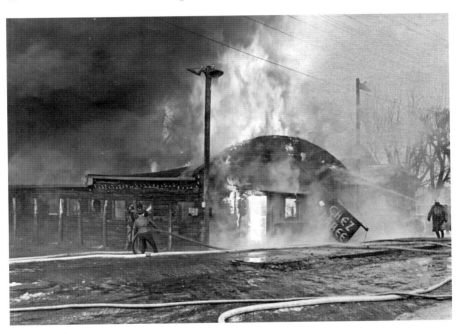

A fire leveled the Chez Paree on February 11, 1942. The nightclub reopened the next day at Third and Locust Streets. *From the* Omaha World-Herald.

Sam Ziegman and Eddie Barrick, the heads of the syndicate that ultimately replaced the Dennison machine in Omaha after its demise in the early 1930s, were among those with a financial interest in the Chez Paree. The pair were no small-timers, as they later moved operations to Las Vegas and invested in the Flamingo hotel and casino. When he died

Volunteers pick up trash along the shoreline across from Mabrey Park on Saturday, April 8, 2006, in Carter Lake. *From the* Daily Nonpareil/*Ben DeVries.*

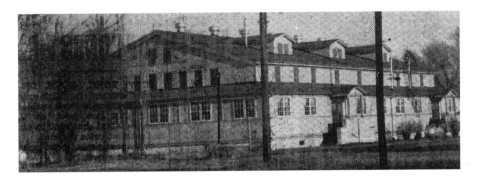

Carter Lake Club Ballroom once hosted what was known as "smorgasbord bingo" games, outlawed by an Iowa Supreme Court ruling in the early 1950s. *From the* Des Moines Register.

in 1979, Barrick was called "America's biggest bookmaker" in his obituary by a Las Vegas newspaper.[176]

The Chez Paree—at one point, with "its rivals, a synonym for Carter Lake"—was closed down in a 1949 sting against illegal gambling, and its original building burned down four years later.[177] The lasting legacy of the site where the Chez Paree once stood is that it is now, quite fittingly, named Mabrey Park after the long-tenured mayor under whose watch it flourished.[178]

A new "establishment [that] operated games of chance…catering to a carefully screened clientele" ran for only a brief while in 1953, and smorgasbord bingo—which was being played at the Carter Lake Club Ballroom—was outlawed by an Iowa Supreme Court ruling that same year. Shortly thereafter, Mabrey assured the *Des Moines Register* that "there is no gambling in Carter Lake now."[179]

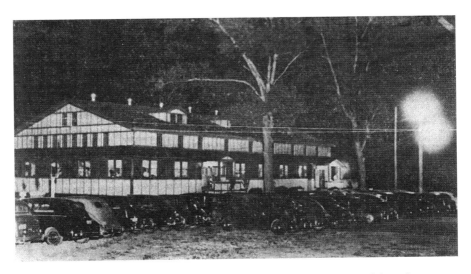

Carter Lake Club Ballroom, as seen in its heyday in 1940, before it burned down in December 1975. *From the* Omaha World-Herald.

The mayor would have known better than anyone else. After a municipal judge found bingo to be allowed under state statute, the state appealed—and both a state judge and the Iowa Supreme Court ruled bingo games were illegal in Iowa, Mabrey decided to enlist the Pottawattamie County attorney and test the waters. More than four hundred people attended a bingo event at which the game was supposedly free, and the food was the only thing for which attendees paid. The mayor was arrested and charged with running a gambling operation, for which he was later found guilty.[180]

But casinos would return to the area—this time, on the east side of the Missouri River—when Iowa legalized wagering on greyhound races in Council Bluffs and two other Iowa cities in the mid-1980s and casino gambling a few years later. Three casinos now operate legally in Council Bluffs, with Bluffs Run (now Horseshoe) opening its doors in 1995 and Harveys (now Harrah's) and Ameristar joining the next year.

Not surprisingly, given the city's past, Carter Lake has been involved in the industry on two separate occasions since casinos made a lawful return to the state.

In 1994, shortly after the Pottawattamie County Board of Supervisors deeded trusteeship of roughly two thousand feet of riverfront land to the city, Carter Lake unanimously approved plans for the Omaha tribe—which continues to operate a casino some seventy miles to the north near Onawa, Iowa—to manage either a land-based or riverboat casino on city land leased

to a developer.[181] A Missouri-based private company, too, later entered the fray with plans to build a riverboat.

After the City of Omaha sued to stop Carter Lake from building on the land, Carter Lake returned fire with a $52.5 million suit alleging "interference in city affairs."[182] Nebraska attorney general Don Stenberg and Governor Ben Nelson went as far as surveying the border and reiterating to Carter Lake's mayor, who felt his city was being "harassed," that the state would not "allow riverboat casinos in Nebraska's waters so long as casino gambling is illegal in the state."[183] In the end, the cities reached a settlement in which the Iowa community paid its larger neighbor $910,000 to drop its claim on the land for the proposed casino.[184]

Instead, Carter Lake found itself on the wrong side of history when the decision came to the Iowa Racing and Gaming Commission in 1995. Neither of its two applications were approved by the state board governing casinos that year, marking "the first time since the legalization of gambling in Iowa that a local municipality had been turned down for a gaming license."[185] While Carter Lake got nothing, two of the three casinos (Ameristar and Harveys, now known as Harrah's) still operating today in Council Bluffs were approved in a decision that led then-mayor Bill Blankenship to consider suing the state board and left Carter Lake's residents feeling overlooked in favor of a larger, more prosperous neighbor—again. As Carter Lake resident Ray Pauly told the *Daily Nonpareil* following the decision, "Carter Lake is still the forgotten part of Iowa. The county has forsaken us. The rich get richer and the poor get poorer."[186]

Carter Lake took one final shot to get a legal casino of its own in 2008. The Ponca tribe of Nebraska explored plans to build a casino in Carter Lake that year, with approval from the city council to discuss the proposal. Kramer thought a new casino could bring up to two thousand jobs—more than half the city's population—in addition to millions of dollars in new revenues. "It's about money," he told the *Daily Nonpareil* after the council approved a resolution. "That's the reason why the Ponca Tribe wants to build, and the reason I as mayor like it."[187]

For once, Omaha officials admitted "the city would have no legal means to oppose a new casino if it were built" in its neighboring city.[188] That didn't stop Nebraska from filing a "similar lawsuit when the Ponca first floated the idea in January, claiming Nebraska has an interest in the case because of Carter Lake's proximity to Omaha."[189] Just two days after the Carter Lake council approved the resolution in August, Iowa attorney general Tom Miller filed a suit to stop the plan in its tracks, arguing "the Ponca Tribe previously had

noted publicly and had acknowledged in writing that the Carter Lake parcel did not qualify as gaming-eligible 'restored lands' under federal law."[190] Although Omaha didn't file suit, Carter Lake's other neighbor and gaming rival, Council Bluffs, voted unanimously to join lawsuits filed by both states. Shortly thereafter, the Pottawattamie County Board of Supervisors voted 4–0 in favor of a resolution to support Miller's lawsuit—just a week after the same body voted against joining either state's legal quest.[191]

Ultimately, a Nebraska judge later blocked the tribe's quest, reversing a 2007 decision made by the National Indian Gaming Commission that the lands were eligible to hold a casino. Council Bluffs officials cheered the ruling, while leaders of the Ponca tribe unsuccessfully pushed a federal judge to reconsider. Subsequent appeals were not heard. Despite the legal defeats, the city and tribe pushed onward, but to no avail. As recently as 2012, officials with tribe's economic outreach arm told the *Lincoln Journal Star* they were still pursuing a casino in Carter Lake. Instead, the tribe operates one of its tobacco shops on Avenue H that provides "much of the economic fuel for the other tribal businesses," with Carter Lake helping the tribe even after their combined attempts to build a casino fell through.[192]

When the second attempt at establishing a tribal casino failed, it put the final nail in the coffin of gambling in this border town. Today, these entertainment options of old in Carter Lake are long gone. Courtland Beach faded into history as other amusement parks in Omaha and Council Bluffs became marquee attractions in the early twentieth century. Meanwhile, the underground gambling that was once rampant in the city has been replaced by legal casinos just a few miles away. Carter Lake no longer has any physical ties to its heyday as a hotspot for the underground.

But that legacy has lived on, with a Carter Lake mother noting in the 1970s that parents from Omaha and Council Bluffs were still reluctant to let children visit the city because of a misguided reputation that "persons interested in wholesome family life had to battle illicit activities."[193] From its early days as a rough-and-tumble border town capitalizing on uncertain boundaries to turning a blind eye to its gambling houses and saloons for years, the city will in inevitably, inexorably be forever linked in some manner to this colorful past.

# FLOODING AND HARDSHIPS IN THE EARLY DAYS OF ONE OF IOWA'S YOUNGEST CITIES

Growing between the hubbub on the shorelines and unclear state lines was a small but hardy community. For many years, the lake that surrounded the city was still fed on one side by the Missouri River. Given its proximity to the river in those days and its low-lying topography, the glorified sandbar that contained a scattered collection of new homes and businesses flooded on a regular basis.

An 1889 article in the *Omaha Daily Bee* painted a grim picture of the young settlement. Several subheadings beneath the main headline—which called the area "no man's land"—told of "the sands of the Sahara" and promised to describe "the inhabitants of the Island, the Houses in Which They Dwell, and the Dust They Swallow, Etc., Etc." The reporter walked from an old bridge at Locust Street. The majority of the road, which both begins and ends in Nebraska, still serves as the main east–west thoroughfare for present-day Carter Lake.

> [H]e didn't, as they say in storybooks, gaze across the broad expanse of waters, principally because there was no broad expanse of that element to gaze across—nothing but mud—green, slimy, odoriferous mud.
>
> Cut Off Island. The name is not euphonious; the place is unattractive. The island, so called, is now really a peninsula, the water having receded in the lake so far northward as to leave a broad strip of mud as a connecting link between the former island and the city.

*Cut Off Island is a big sand-bar, that is all, destitute of trees, unless by a stretch of imagination the scrubby young willows that grow in nearly impassable density and cover the island, except where they have been cleared away by inhabitants, can be called such.*[194]

Yet after many summers of high waters, the few hundred gritty local residents waded back into their town to recapture and rebuild on this misnomer of an island.

The first recorded flood at Omaha was caused by an ice jam that broke near Yankton, South Dakota, on April 1, 1881. Three people were killed by floodwaters in northeastern Nebraska in the immediate aftermath.[195] The ensuing wall of water, which made its way to Omaha five days later, caused damage estimated to be in the millions of dollars in the currency of the time. The present-day city of Carter Lake had not yet been settled, which was fortunate, as it was also under several feet of water.

At that time, a flood of such magnitude had not yet been seen in the young city. A large portion of the existing system of riprap—crushed rock used to prevent erosion and flooding along riverbanks—likely installed by the U.S. Army Corps of Engineers, reportedly "gave away like cheesecloth."[196] Several feet of water submerged the Union Pacific rail yards, which were built on the floodplain near the town of Carter Lake, though enterprising businessmen figured out how to conduct trade despite the swollen river.

*As the smelter closed, the Union Pacific's 50-acre rail yard was under so much water that steamboats were able to travel inland and take out coal while their shops, which employed more than 1,000 men, were threatened and wood from their lumberyards broke loose and floated freely. When the water crested at 25 feet, two feet higher than ever previously recorded, it was covered with floating ice chunks, trees and debris as far into the city as Ninth Street and as wide as five miles in places.*[197]

From there, the river "water, which was yellow with clay and debris from cornfields, trees, and houses," forced many onto their roofs to evacuate.[198] And the memory of the flooded rail yards would play a role in the next major flood to slam Carter Lake.

As the Missouri River, fed by two feet of snow upriver that melted suddenly because of a spike in temperatures, rose in April 1943, it forced its way through a dike protecting Carter Lake and northeast Omaha. The force of the river found a weak spot in the flood-control system, creating a twenty-

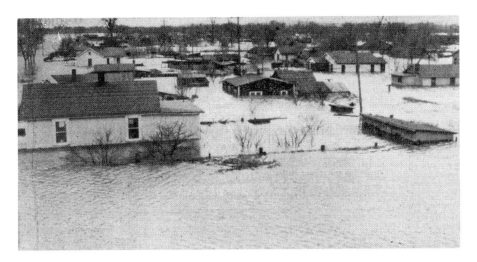

About 250 families evacuated their homes in East Omaha, Nebraska, before a dike broke north of their area during the 1943 flood. *From the* Des Moines Register.

foot hole that left Carter Lake and Omaha's municipal airport right in the river's crosshairs once again. Within twenty minutes, the *Des Moines Register* reported, "water had spread over an area a mile and a half wide and was fast approaching the airport nearly two miles from the dike hole."[199]

Although the desperate work of an estimated 2,300 soldiers and civilian workers at first appeared to have "won their battle upstream from Council Bluffs, Ia., and Omaha," the flood crest of 22.5 feet and gushing water from a sand boil that formed on the dry side of the levee forced the workers to make a hasty evacuation. (The National Weather Service reports the 1881 flood crest at Omaha as 34.22 feet, as measured under the former Ak-Sar-Ben Bridge linking Omaha and Council Bluffs, now both Interstate 480 and U.S. Highway 6, making it the third-highest ever reported.)[200]

The article in the *Des Moines Register* reported that East Omaha saw 250 homes evacuated within hours of river breaching the levee. Nearby, an estimated one thousand people were forced from their homes in the Carter Lake area, as a new levee on Locust Street failed against the water, joined by one just to the southwest along the industrial district on Omaha's Grace Street. The Missouri River found its way back to the dry lakebed of the former Lake Florence to the north of the town "and inundated the airport with seven feet of water in 18 hours"—and Carter Lake was directly in its path.[201] But the Iowa city on the Nebraska side of the river suffered one of the hardest hits of any community during the 1943 flood. Many residents

believed officials chose to save the rail yards at the expense of Carter Lake. As Simpson wrote:

> *This levee was destroyed by the Corps of Engineers during the spring flood of 1943 to save the Omaha railroad yards, power plant, and the low-lying sections of the Omaha business district. The community of Carter Lake was flooded resulting in severe damage to homes and property. At the time many of the residents, especially in the Carter Lake Club area, were deeply resentful of the actions of the army engineers. This hostility was directed at the mayor of Carter Lake who, they believed, could have prevented the action with a protest.*[202]

With the destruction to Carter Lake as no doubt at least a small factor, the flood of 1943 was the inspiration for the dam system that currently serves as a portion of the Missouri River's flood control in the Dakotas. In December 1944, Congress approved the Flood Control Act, which included the Pick-Sloan Missouri Basin Program, the first effort at a "complex water control plan along the entire Missouri River Basin" and created the existing structure of dams and man-made lakes.[203] The last of these, Gavins Point Dam, is roughly 150 miles upriver from Carter Lake.

Drowned but not dead following the worst flood in more than sixty years, Carter Lake would again return and rebuild, as it always had. But Carter Lake residents would again be forced to evacuate by the highest crest the Missouri River has ever produced in Omaha less than a decade later.

Again, heavy winter snows and unseasonably warm spring temperatures, coupled with the still-unfinished dam system upriver, caused yet another flood. A meteorologist in Sioux City expressed concern in March, noting the "winter snowfall and precipitation ranged between 155 percent to 460 percent more than normal and predicted quickly-melting snow would bring flooding."[204] But the resulting flood was unlike any other ever seen in or around Omaha, as the "'Big Mo' was roaring drunk on a snow-melt cocktail which could have been mixed by Paul Bunyan." The wild river ensured an "unprecedented volume of water rolled over towns and farms for a thousand miles, into a bottleneck at Omaha and Council Bluffs.[205]

To this day, the flood of 1952 remains the flood of record at Omaha, whose official measurement is taken just a couple miles to the south of Carter Lake. Though many of the news sources of the day report the crest at between 31.0 and 34.0 feet, likely because of different locations used for measurements, the National Weather Service lists the crest at 40.2 feet, 11.2

feet above flood stage—nearly 4.0 feet higher than the devastating flood of 2011, the longest flood event in U.S. history, and the flood of 1881, until then the flood of record and maximum amount of water the levee system at Omaha was designed to hold.[206]

With advance notice from upstream, the entire city of Carter Lake was placed under an evacuation order, with its residents among more than seventy-five thousand in Iowa and Nebraska forced from their homes as the water rapidly rose.[207] Countless stories of heroism and determination to help out highlight the teamwork and cooperation needed to keep an angry, swollen, rising river at bay, including many from other towns or states who offered to help fortify the levees, neighbors who hadn't talked in years filling sandbags together and a "Jesuit priest, turned down as too old, waited around the corner for a dike-bound truck and was smuggled in" to aid in the efforts.[208]

Volunteers and soldiers worked around the clock to build up the levees and dikes, with Council Bluffs, for instance, installing a four-foot-high flashboard of lumber, two feet of dirt and additional sandbags to buffet the river's advance.[209] All in all, between Omaha and Council Bluffs, "[o]ne and a half million [sandbags] were filled and tied, often by hands bearing lacerations from binder twine."[210] President Harry Truman flew in to survey the damage, declaring the region a federal disaster area. While in town, he met with "seven governors and four U.S. senators from affected states from which federal promises of not only flood relief but support for further flood prevention programs were gained."[211]

Though the levees in Omaha held and kept Carter Lake protected from the worst of the river, the low-lying city still found its streets underwater. In some of the flattest floodplains, the river is said to have stretched as wide as sixteen miles at points. In the end, however, a flood that did millions of dollars worth of damage and tens of thousands of evacuations caused no deaths and only one injury—that of a traffic accident in Omaha.[212]

Shortly after the flood of 2011, the one hundred days' flood, began, *Lincoln Journal Star* history columnist Jim McKee noted, "'The river is not considered a flood threat for the Omaha area,' some experts say"—a point many residents of Iowa and Nebraska will now vehemently contest.[213] But despite that, Carter Lake, protected by levees beefed up following the flood of 1952, for once avoided the worst of a flood event. Though residents and volunteers filled thousands of sandbags and officials released an evacuation plan in 2011, little more than sporadic basement and shoreline flooding along the lake was reported.[214]

Members of the U.S. Coast Guard take part in training exercises at Carter Lake during the Missouri River Flood of 2011. *From the* Daily Nonpareil/*Cindy Christensen.*

In the earliest days of Carter Lake, floods no doubt were the greatest threat to the hardy community's residents. But the infant city found itself in a strange situation, too, in regards to its public safety.

Fire protection was long an issue in Carter Lake's earliest days. When the city remained a part of Council Bluffs, it often took half an hour or more to get fire equipment across the Missouri River and through Omaha. Accordingly, "even minor fires cause[d] considerable damage and in some instances total loss." Carter Lake officials claimed a subsequent agreement with Omaha, once again, resulted in payments to the larger city and services that failed to be rendered, with Omaha later discontinuing the practice of providing fire protection to neighboring communities.[215] Furthermore, the city once faced fire insurance rates that far exceeded those of nearby towns.

In response, Carter Lake formed its own volunteer fire department in 1957. This practice is common in towns both smaller and larger than Carter Lake. Its first fire hall was a total loss after it burned down in 1974 and destroyed three fire engines; in response, the volunteer force's rebound "can be compared to a mythical Phoenix rising from the flames."[216] With trucks, vehicles and other equipment lent to Carter Lake by Council Bluffs and other nearby cities, the department managed until insurance money and fundraisers by its still-active auxiliary got the unit fully back on its feet.[217]

Today, the department remains vibrant and active in the community, although it has long battled dwindling numbers. With the force's active membership at only twenty in 1994, for instance, the *Daily Nonpareil* reported nine retired firefighters were often called into service to help during times when manpower was short, particularly during daytime hours—a common problem among volunteer departments where many members work full-time jobs.

Even today, Carter Lake struggles with smaller numbers than in years past despite the fact roughly two-thirds of its thirty-four firefighters—a significant jump from twenty years prior—lived within the city limits in 2014. Part of that, fire department coordinator Phillip Newton told the *Daily Nonpareil*, is due to the demands of balancing work, family and service in a volunteer unit under the high standards set forth by the State of Iowa. "I know the people want to do it, but once they get here, they realize how much of a true commitment it is," he said. "There's nights where they don't get to sleep, and the next morning, they have to get up and go to work the next day."[218]

The Carter Lake Volunteer Fire Department also operates one of southwest Iowa's only water rescue teams, one that has survived recent attempts to cut or temporarily suspend its funding to address budget shortfalls. Mayor Gerald Waltrip, who has questioned the need for such a unit during his third stint as mayor, told the city council in 2014, "Most of the time, it's too late (for water rescue). I don't think water rescue is a big deal."[219] Although Newton estimated that the water rescue team is deployed roughly ten times a year, the council voted 3–1 in June 2014 to keep it intact. "If we live near a body of water, I believe it's essential we keep the water rescue that we have," Councilwoman Barb Malonis said shortly before the vote.[220]

Law enforcement in Carter Lake, too, has been the center of controversy throughout the years. For even the simplest law enforcement action, such as executing an arrest warrant, the murkiness of state lines could be a hassle. The news briefs mistakenly listed under an "Omaha news" headline in the Council Bluffs newspaper lists just one example. The *Daily Nonpareil* told the story of a Job Haycock, a fugitive wanted on embezzlement charges from New Jersey, who was holed up on what was then known as Cut-Off Island in 1889. The suspect, however, "refused to go without requisition papers, and (Officer) Summers went to Lincoln to get them."[221] Even though the arresting officer was making an arrest on what was and always had been Iowa soil, he sought a warrant from a Nebraska judge.

In the late 1890s, the Omaha Police Department pulled its protection from Carter Lake. Over the next century, Carter Lake formed its own police

force—one that has weathered and moved past a seemingly revolving door of chiefs and officers amid years of political infighting with city leaders to maintain a level of stability. For instance, some members of the city council sought in 1976 to disband the city's reserve police unit, which served as backup units to the Carter Lake Police Department's sworn officers, amid allegations of "harassment and brutality."[222] When the motion to formally dissolve the unit died after failing to gain a second, the audience broke into applause.

The Carter Lake City Council in 1979 explored the option of contracting with the Pottawattamie County Sheriff's Office; agreeing to do so would have led to the "dismantling of the city's Police Department" after the city had shuffled through five police chiefs in less than two years.[223] Over the course of a few months, city leaders, law enforcement agencies and residents grappled with the proposal, which would have required the city to fully fund the positions in a move that would have been "awful close" to budgeted figures. In 1980, though, the city council voted "to keep local law enforcement in Carter Lake" rather than explore the possibility of a contract agreement with the sheriff's office like many of the county's smaller communities.[224]

A Pottawattamie County grand jury soon issued harsh criticism to Carter Lake's elected officials, much of which was centered on their handling of the police department. Though no one was indicted, the recommendations included a comprehensive review of hiring and performance reviews of its chief and officers while noting "the lack of training and ability of the officers."[225] The turmoil that had engulfed the department was the most visible example of what the grand jury report called "a rather disturbing picture of Carter Lake, Iowa, and the ability of its residents to get along."

Eventually, the community's small police unit was overwhelmed with crime from the same larger neighbor that once protected the Iowa town. In the twenty-first century, however, that trend appears to have reversed itself. By 1990, Carter Lake had earned the top ranking in Iowa for violent crime per capita. That figure, according to both statistics and the police chief at the time, could be attributed to two things: the city's small population (around 3,200 at the time) and its proximity to higher-crime neighborhoods in North Omaha. Although Carter Lake ranked first in murders per capita in 1990—also topping the state in aggravated assaults and finishing second in motor vehicle thefts—the city reported all of one murder that year.[226]

Police chief Bob Warner said in 1992, as Carter Lake was losing its ignominious No. 1 ranking, that his city had "340,000 problems in our

backyard," referencing the population of its western neighbor.[227] Until 2010, Nebraska state law mandated bars to close at 1:00 a.m., an hour earlier than Iowa bars, and an intoxicated, unruly crowd often headed across state lines to squeeze in one final drink. For many, Carter Lake was closer or easier to access than Council Bluffs for that nightcap, leading to an "extra hour of drinking, and the resulting revelry often leads to assault reports."[228]

Omaha's population, Warner added, was responsible for 95 percent of his community's crime. "It's not our people," he told the *Daily Nonpareil*. "It's the crumbs coming through."

To this day, any criminal suspect arrested by the Carter Lake Police Department is transported to the Pottawattamie County Jail in Council Bluffs. Though, as the crow flies, the jail is slightly more than two miles from the edge of Carter Lake, it is accessible only with a detour through Nebraska that is more than triple the distance—as "inconvenient as it is necessary."[229] Conceivably, like so many things regarding Carter Lake's location as a border town unlike any other, this could lead to questions about jurisdiction if someone pressed authorities, but it has apparently yet to do so.

# LAWMAKERS IN TWO STATES CONTINUE TO BATTLE OVER CARTER LAKE'S LOCATION

Before Carter Lake had even been incorporated, several Nebraska lawmakers began to champion the idea of reclaiming Carter Lake from Iowa as the city began to grow and prosper. The Supreme Court decision in 1892, though the ultimate law of the land handed down by its highest court, failed to deter Nebraska's desire for a burgeoning city and the associated tax revenue. Simpson wrote that while the Supreme Court ruling "has never been altered, it has been attacked many times" by aggressors in Nebraska.[230] And for most of the community's history, elected officials and residents alike have spent decades worried about what would happen if Nebraska got its way.

"It sort of keeps them on edge," Mabrey said in 1960. "And definitely it keeps those of us in office wondering what is going to happen."[231]

Even before Carter Lake was a city, one that tried to join Omaha, its representatives were concerned about possible claims by Nebraska despite the 1892 ruling. In November 1923, state senator W.S. Baird told a Council Bluffs Kiwanis Club luncheon about a bill that passed the Iowa legislature. Baird inserted—and successfully defended—an amendment "that helped to keep Carter Lake in this state, which read: 'The state of Iowa shall preserve the boundary line as it now exists between Iowa and Nebraska, between the cities of Council Bluffs and Omaha at a point called Carter Lake.'"[232]

Throughout the years, a handful of boundary committees consisting of elected officials or business leaders from both Iowa and Nebraska have

convened to determine the state line. In 1925, an overzealous Nebraska legislator tried to claim the entirety of Council Bluffs at one of these commissions, a suggestion that was laughed off by Iowa. But the next year, the Iowa representatives unanimously agreed "that the boundary line between the states of Iowa and Nebraska should be established at the center of the Missouri River as it now flows"—the first maneuver that indicated Iowa would be willing to give the Carter Lake area to Nebraska.[233] With it, any future changes in the river's course would have led to linked adjustments in state lines.

This followed the defeat of a proposal, deadlocked at three votes apiece and split along state lines, that would exempt Carter Lake from the measure and leave it in Iowa despite a redrawn border. Furthermore, three Iowans on the commission suggested the Iowa legislature be given the authority to renegotiate the boundary between the states. This maneuver circumvented the "pressure brought to bear by Council Bluffs officials" that specifically stripped the commission to reestablish the border separating Pottawattamie County, Iowa, from Douglas County, Nebraska.[234] As the *Omaha Daily Bee* wrote following the decision, "If that is the case, it is probable that the Carter lake district will, in a few years, become a part of Nebraska."[235] But no action was taken on the proposal, nor did a 1935 push by Omaha mayor Roy Towl gain any ground.

Nebraska also attempted to use land south of Lake Manawa, site of one of the amusement parks that hastened the demise of Courtland Beach, in the 1940s as a bargaining chip to obtain Carter Lake. A 1941 map in the *Nonpareil* incorrectly shows nearly all of Lake Manawa and other land to the south as being within Nebraska's borders; only a small sliver of the lake had ever belonged to Nebraska, and the section of the lake in question had been ceded to Iowa in 1919.[236] This land, too, was an exclave, a newly formed four-hundred-acre oxbow lake that had once been a portion of eastern Sarpy County, Nebraska, and found itself on the other side of the Missouri River after "river movement and subsequent redefining of Nebraska's eastern boundary" from the flood of 1881.[237]

The Cornhusker State's proposed swap would have, coincidentally, ensured that it would gain Carter Lake in exchange for the lake and surrounding areas—including the current site of the MidAmerican Energy power plant that serves Council Bluffs. The *Daily Nonpareil* reported the land near Manawa was considered to be "of so little value that it is understood Nebraska does not even assess it for taxes.[238] Even in 1925, Council Bluffs mayor Jack Harding scoffed at the thought: "Omaha with its almost

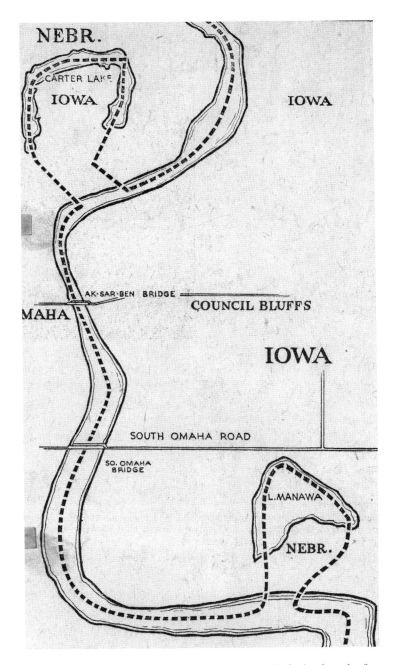

In 1941, Nebraska proposed to exchange Carter Lake for land south of Lake Manawa that later became part of Iowa through a 1943 land swap between the states. *From the* Daily Nonpareil.

complete lack of industrial sites naturally looks with selfish eye upon East Omaha. What have they to offer for it[?] A little mangy tract of swamp and sand below Lake Manawa. Let's forget it."[239]

Just two years later, in 1943, Iowa and Nebraska agreed on a one-time land swap, operating under the assumption that the Missouri River had been forever tamed and "permanently harnessed" by the Army Corps of Engineers.[240] With it, their borders would be redrawn at the Missouri River channel of 1943, including the land near Lake Manawa that Nebraska sought to swap two years prior. Carter Lake, of course, was exempted from this trade, as Iowa insisted its city remain within its borders. This boundary change moved "land, not people," and the proposed transfer of an entire city to another state was unprecedented in Iowa.[241] The states soon learned, however, that the task was far from complete, as evidenced by the flood that evacuated both Iowa and Nebraska residents alike, including the entirety of Carter Lake.

But officials overlooked one critical step before making their agreement—a survey of the river channel—that would keep the issue alive for decades:

> *Unfortunately, both states neglected to inform the Army Corps of Engineers of their need for a 1943 map of the river channel, so no official survey or map was made. In addition, with the progress of World War II, the Corps had more pressing tasks to perform than the stabilization of the Missouri. Because of the lack of stabilization, the river broke loose from the 1943 channel.*[242]

The appetites of the Nebraska legislators who coveted Carter Lake were insatiable. In 1947, a central Nebraska state senator proposed yet another piece of legislation, hoping to swap Carter Lake for land south of Plattsmouth, Nebraska, some twenty-five miles to the south. The *Daily Nonpareil*, however, asked the lawmaker to "kindly locate the land" in Mills County, Iowa—only for the senator to be "given an embarrassing lesson in geography" when he was informed no Nebraska land was east of the river in that entire county.[243]

Caught red-faced but still unfazed, the lawmaker changed his tune—only slightly. The newspaper reported: "Admitting he had been misinformed, he emphasized he is still interested in obtaining Carter Lake. Instead of trading, he suggested a cash payment would be in order. He said the bill would remain before the legislature."[244]

When an out-of-state professor wrote to the *Daily Nonpareil* later that year to inquire about the situation that created the geographical exception that

is Carter Lake, the newspaper responded with absolute certainty about the community's location: "Carter Lake district is still part of Pottawattamie county and will remain a part of Iowa no matter what changes the capricious Missouri River brings about in the future."[245] However, the Missouri River, despite its flood of record five years later, would not be the agent for change; it would instead be the far more capricious whims of politicians in both Iowa and Nebraska.

Another such boundary commission that first met in 1956 debated whether to again use the center of the Missouri River "as a floating boundary for the two states," as was decided thirteen years prior—which would have left Carter Lake mired in uncertainty. Both Mabrey and Representative Ben Jensen, a thirteen-term congressman from the western Iowa community of Exira who represented Carter Lake in Washington, pushed for a referendum, one that ultimately never came. If it had, the pair presumed it would reflect residents' overwhelming desire to remain in Iowa. "Let the people pick their state. That's representative government," Jensen told the *Daily Nonpareil*. "And I don't give a dang whether there's precedent or not."[246] Such a vote never materialized, although all accounts indicated a pro-Iowa majority would have won handily. Many residents of Carter Lake openly expressed a fear, if annexed by Omaha, of becoming like East Omaha, which they felt was "treated as a 'step-child' [sic] by the parent city and as a result has assumed many aspects of a slum area."[247]

Besides, as Councilman Ted Ortiz—now the namesake of a city park—said in 1957, Carter Lake had much enjoyed the ability to control its own destiny in a way that would have been impossible if the city were to be absorbed into Nebraska: "Why not leave things as they are. This is Iowa. Let it stay Iowa."[248] Added DeVere Watson, the Council Bluffs lawmaker who served as Carter Lake's first city attorney: "The State of Iowa will be giving away a bonanza if it lets go of Carter Lake."[249]

When the latest newly formed boundary commission met in 1960, history repeated itself for the umpteenth time: Nebraska's representatives wanted Carter Lake to leave Iowa, while Iowa's representatives said they would not let it happen. But Nebraska remained as bold as ever in its pursuits, which appeared to reach a fever pitch this time around.

Robert O'Keefe, secretary for the Nebraska delegation to the commission, bluntly told the *Omaha World-Herald*: "I don't only want it in Nebraska; I want it annexed to the City of Omaha. And that's what I'm going to fight for….Carter Lake people buy their food and their cars here; they work in Omaha. And they ought to be part of Omaha." A former commission chair

from Nebraska, Louis Pentzien, further added: "When sane-minded people get together and Mr. Mabrey steps out, this will be settled."[250] In an Iowa newspaper that same day, Mabrey tore into the "greedy political mongers" who were trying to exploit Carter Lake for their own gains while standing firm that his city was going nowhere. "We went to the [U.S.] Supreme Court once before and won," he told the *Daily Nonpareil*. "We can do the same thing again."[251]

Even a joint boundary commission to be held in Carter Lake on September 17, 1960, was a point of contention between the body's representatives. It was widely known that "at least 95 percent of our people," Ortiz said, planned to express their strong desires to stay in Iowa, even though no formal poll could be taken of the city's residents.[252] Incensed, O'Keefe—who said he was "pretty hot about the situation"—threatened to boycott and encouraged the rest of his state's delegation to do the same.[253]

An estimated two hundred Carter Lake residents showed up for the meeting. Many remarked they had moved to the city to escape Omaha, while one deadpanned that Omaha should instead give Carter Lake the airport and nearby East Omaha. Helen Aulmann, always one of the city's most strident advocates, told the lawmakers, "I see no reason why these darned politicians can't keep their hands off it." When asked about their preferences, every person in the room raised their hands as one to indicate they wanted to remain in Iowa, which led Iowa senator Frank Hoxie of Shenandoah to comment that "he hoped the rest of the nation was as unified as the people of Carter Lake."[254]

Despite the unity among Carter Lake residents, a 4–2 majority of the Iowa commission voted three months later to fix the Missouri River boundary as it ran in 1960 as the state line—a move that set in motion plans to officially transfer Carter Lake to Nebraska.[255] Some members expressed hope that yielding the community to its western neighbor would allow Iowa to "proceed with development of recreational facilities along the river."[256]

Still, the path to changing the city's statehood was long and arduous. Both states' legislatures needed to approve the measure, with Congress providing the final green light if it received approval from Iowa and Nebraska lawmakers. The Nebraska commission was, unsurprisingly, pleased by the decision, calling it the "best advance ever made for both sides of the river for all purposes." But those affected by the game of political chicken were irate, feeling as if they'd been sold downstream by fellow Iowans.

After news of the decision reached Carter Lake, a livid Mabrey, most strongly expressing the opinions of all residents interviewed that day by the *Daily Nonpareil*, told the newspaper: "We're going to get a fish and wildlife for a birthright—2,500 people and $4 million worth of property for a

few thousand acres of worthless river bottom land—isn't that a [hell] of a trade?"[257] The Pottawattamie County Board of Supervisors swiftly came to bat for its community, with all five members supporting a proposed resolution to keep Carter Lake in the county and Iowa, with one supervisor expressing grave concerns the "commission disregarded the right of the people in Carter Lake."[258]

Carter Lake then took its battle to the golden-domed state capitol building in Des Moines. Residents swarmed lawmakers with letters and phone calls, with Iowa representative Vern Lisle of the southwest Iowa community of Clarinda noting, "They are proud of being Iowans and want to stay that way. Well, I say, here's to them."[259] Mabrey pressed the Iowa General Assembly to "approve a boundary at mid-river EXCEPT for Carter Lake."[260] Such a move, he said, would end the controversy that engulfed his community and allow it to have the needed certainty to continue to thrive. To do that, Iowa legislators would have to give thumbs-down to a plan that would have netted the state a total win of four hundred acres of land.

However, the state's legislature sided with Mabrey and his community, voting in 1961 to kill Nebraska's effort and to keep Carter Lake in Iowa—a place it had never legally left, despite such numerous, fierce attempts to bring it to Nebraska. (Representative Lisle was listed as present not voting on the issue, for some reason.) Both houses of the Iowa legislature voted not only to keep Carter Lake in Iowa but also to "establish a new boundary of the river except in Pottawattamie County."[261] Within the week, Iowa governor Norman Erbe signed the measure into law. Nebraska legislators were, unsurprisingly, upset with their eastern neighbors, with one state senator calling Iowa's decision "the most asinine thing I ever heard of," while a counterpart pulled plans to introduce a bill that would address border discrepancies.[262]

Iowa representative William Darrington, who hailed from the town of Persia in nearby Harrison County, opposed the transfer of Carter Lake on the boundary commission. He voted against it again when the measure reached the Iowa House, and, after the decision, expressed one of the few outside voices to contemplate the human cost of possibly relocating an entire city against its will:

> *If it was only a matter of turning over to Nebraska these 1,600 acres on the other side of the river, I would vote for it in a minute. But I cannot disregard the human considerations that are involved. I feel that it would be morally wrong to turn these people over to Nebraska and what is morally wrong is politically wrong.*[263]

When Nebraska lawmakers again pushed to claim Carter Lake for their state in 1963, their advances were immediately rebuffed by Iowa legislators—even though a bill was introduced in Des Moines by two lawmakers from near Sioux City who wished to develop recreation sites along the riverfront on Iowa land on the Nebraska side of the river.[264] A new boundary committee was formed, which included one of the Iowa lawmakers behind the failed 1963 transfer. Again, this subset of elected Iowa officials voted to give Carter Lake away, but their colleagues refused to go along.

With the Iowa General Assembly's clear majority vote in 1961 and the continued wish of Carter Lake residents to remain in Iowa, the majority of the state's lawmakers believed the debate was dead and that a "substantial change in conditions would have to come before it is worth while [sic] to open it again."[265] All the while, Carter Lake residents begged to just be left alone. Iowa had been good to them, they pleaded, and they were tired of seeing "the Iowa commission have to bow down to a few selfish Omahans."[266]

But as had been the custom for the bickering neighbors, just as the scab had begun to heal, it was torn clean off the next year. Nebraska again took Iowa to the Supreme Court in 1964, claiming the Hawkeye State had violated the 1943 agreement between the states to use the center of the Missouri River channel as the common, floating boundary line. Although Carter Lake was not an integral part of this lawsuit—which instead focused on so-called aggressive policies by Iowa regarding alleged expropriation of Nebraska taxpayers' property and the state's claims to prime recreation, hunting and fishing lands along the riverfront—the meandering Missouri again proved problematic for relations between the states.[267] As Nebraska lawyers argued, two sizable chunks of property in counties south of Carter Lake supposedly deeded to Nebraskans but claimed by Iowa were the impetus for the suit.

Property rights and questions about which states owned which exclaves reached a frenzy—to the point where "an Iowa game warden seeking to pinpoint the actual state boundary was shot at."[268] Carter Lake, the sticking point for so many Iowa legislators to accepting an across-the-board agreement on a full middle-of-the-river boundary, was viewed by many as the cause for tension in both states. Iowa stood accused of "interfering with the rights of citizens of either state which were secured to them by the laws of Nebraska prior to 1943."[269] After hearing arguments from both Nebraska and Iowa on January 25, 1965, the Supreme Court, "intrigued by the uniqueness of the dispute," granted permission for Nebraska to file suit on February 1, 1965.[270]

The Des Moines Register editorialized in favor of Nebraska's points in 1965, arguing that Iowa would win by gaining 2.5 acres of land for every acre

it would give up and allowing the aforementioned riverfront development to take place. "However much Iowans love the town of Carter Lake and however much Carter Lake residents prefer Iowa to Nebraska," the newspaper wrote, "the logic of a middle-of-the-river border is inescapable. Carter Lake, by its location, is irretrievably linked to Nebraska rather than Iowa."[271] Even Iowa governor Howard Hughes wanted to be rid of Carter Lake—so much so that "he has said repeatedly that if he had the power, he would give it away immediately"—so that his state could capitalize on the river bottom land, a point on which the *Daily Nonpareil* demanded in an editorial that the governor explain "why he is so obsessed with giving these people and their property away.[272]

Carter Lake had been spurned by a subset of Iowa lawmakers to be sold out to Nebraska. Even the state's largest newspaper, some 125 miles away in Des Moines, opined that "it is high time for Iowans to recognize further development of the [Lewis and Clark] trail is more important than retaining Carter Lake as part of Iowa."[273] Both the governor and the *Des Moines Register* echoed the same points: warning of emotional attachment issues to Iowa by Carter Lake and urging people to look at the greater good for the state of settling the boundary dispute once and for all.

Yet the island community's dedication to the state of which it had always belonged never wavered, particularly considering many of its residents moved to town to escape Nebraska. Undoubtedly, some of those feelings could likely be traced to the 1920s. Older residents who remembered Omaha's complete apathy when Carter Lake sought to join its much larger neighbor to the west pointed out the hypocrisy of the situation. "Back when we wanted in their damn city, they couldn't see us for dust," a sixty-seven-year-old told Simpson in 1960. "Now we are growing and worth some money, they want our taxes."[274]

Among Mabrey's more creative efforts to convince lawmakers that his city must remain in Iowa came in 1965. The mayor entered into a partnership with the *Daily Nonpareil* to have the newspaper print and mail 1,500 brochures telling Carter Lake's story to the entirety of the Iowa General Assembly, a move that opposed Governor Hughes's interest in ceding the city to Nebraska. The pamphlets were to be mailed to both the home and office addresses for 183 legislators.

Charles Huff, publisher of one of the few newspapers—if not the only one—that advocated state officials not to dangle the city as a trading chip with Nebraska, told one of his reporters: "We want to show the legislators that Carter Lake residents are firm in their stand to keep the community

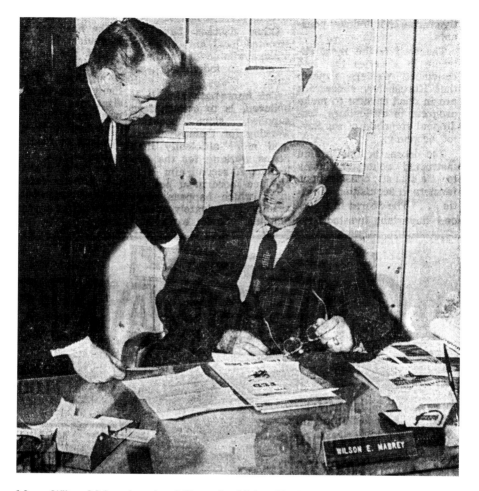

Mayor Wilson Mabrey (*seated*) and *Nonpareil* publisher Charles Huff discuss a brochure that would soon be sent to all Iowa legislators, 1965. *From the* Daily Nonpareil.

in Iowa. Most of the property and people have always been in Iowa, and we still maintain that it is unconstitutional to give away people and their property without a vote of those involved."[275]

The only thing as constant as Nebraska's coveting of Carter Lake as its own was Mabrey's determination to ensure it remained in Iowa, per the will of the people who elected him. As the *Des Moines Register* said about the mayor in 1973, "In pursuit of those goals, Mabrey has tracked through courtrooms and legislative halls; he's usually won and he's left a number of state officials

with a grudging respect for his perseverance."[276] Mabrey instead insisted his efforts were nothing more than representing his constituents:

> *Over the years, many residents have seen their homes perish from floods, only to build and rebuild again. They were born in Iowa and they want to stay here. New residents moving into the recent housing developments say: "If we wanted to live in Nebraska, we would have moved there in the first place!"*[277]

Nebraska's case against Iowa was ultimately heard by the Supreme Court in 1972, and the nation's highest court again ruled unanimously in favor of Iowa. The nine justices ruled Iowa had not violated the 1943 accord, concurring that while Nebraska had the better claim to exclaves formed prior to 1943, Iowa more convincingly held those formed subsequently by the river. The court, in noting the 1892 decision regarding the area remained the law of the land, admitted that "[i]n the past thirty-five years, the river has changed its course so often that it has proved impossible to apply the court decision in all cases, since it is difficult to determine whether the channel of the river has changed by 'the law of accretion' or 'that of avulsion.'"[278]

Even as recently as 1990, Nebraska had again floated the idea of taking control of Carter Lake. As the states pursued a mutual, reciprocal land swap to rectify exclaves on the wrong side of the Missouri River, the Council Bluffs lawmaker in charge of the Iowa Boundary Commission and Carter Lake officials considered the idea of giving Nebraska the community that had grown to become Pottawattamie County's second-largest city as "non-negotiable." Emil S. Pavich, a member of the Iowa House of Representatives, said losing the $40 million in taxable valuation for Carter Lake would cause a major shortfall in funding both Council Bluffs and Iowa schools.[279]

In explaining his decision to the *Daily Nonpareil*, Pavich also touched a nerve and a common feeling, whether intentionally or not, among the residents of Carter Lake: "Carter Lake is a big plus for Iowa," he said.

In his comments, Pavich also echoed the words of Mabrey from more than three decades prior. The longtime mayor pointed out the tax revenues Carter Lake placed into state coffers, a major reason Iowa lawmakers have continued the fight to keep the city within its borders, and Mabrey couldn't "imagine the State of Iowa wanting to give that away."[280]

As Carter Lake's staunchest defender, its longest-serving mayor, told an Omaha newspaper in 1965, "As mayor of this city, I feel it is my duty to

defend the rights of the people I represent. It is the popular desire of the people of our city to remain citizens of their rightful state by birth....We feel that the constitutional rights of 3,000 Iowa citizens are more important than any other consideration."[281]

# VIBRANT CITY GROWS DESPITE GEOGRAPHY

For most of its history, Carter Lake has been a growing community, filling out the peninsula on which it resides. Given its status as a portion of Council Bluffs when it was incorporated in 1930, the exact population of the community at that time is uncertain. Estimates place it at between 350 and 400. Between 1950 and 1960, its population nearly doubled, increasing from 1,183 to 2,281.[282] Eighty years after Carter Lake's founding, it had grown roughly tenfold.[283]

This boom can be attributed several factors. First, the small immigrant-owned dairy farms that once dotted the landscape soon folded, yielding their land to housing developments. Next, the opening of Abbott Drive—a direct route linking downtown Omaha to Eppley Airfield—in 1956 provided a perfect front door to Carter Lake. This served a twofold purpose: replacing the "overcrowded, poorly maintained traffic-laden" North Sixteenth Street while also placing Carter Lake just a short drive from the metro area's two principal cities.[284]

While much of the uncertainty surrounding the city has been put to rest, remnants of its strange birth and ongoing battle against Mother Nature have kept some of its oddities preserved. Most notably, the city lacks a true business district, including a grocery store. The following observation from Simpson's study in 1960 remains true today: "Carter Lake must look to (Omaha) for medical and health services, for most repair services, for legal advice, for retail goods and commercial recreation."[285]

Though a sign on Abbott Drive asserts that the "Carter Lake Business Area" is directly to the west, this commercial strip does not resemble the

Carter Lake city clerk Doreen Mowery holds a cake depicting a hole planned for Shoreline Golf Course that cost Carter Lake $5.8 million. *From the* Daily Nonpareil/*Kevin McAndrews.*

typical main drag seen in Iowa. Rather, Locust Street, the major east–west thoroughfare, begins and ends in Nebraska, dead-ending into North Omaha's main artery, North Twenty-Fourth Street, and petering out near the Missouri River after passing through Carter Lake.

Locust Street in Carter Lake has a city hall and a smattering of shops, gas stations, a senior center, restaurants and a bank, though an increasing

number of local favorite eateries in Omaha and Council Bluffs have begun to take interest or build along this road. An eighteen-hole golf course aptly named Shoreline is on the western edge of the city of Carter Lake; not surprisingly, the body of water comes into play on both nines. The driving range is close enough to the Nebraska state line that an errant tee shot to the left can nearly be hooked into the Cornhusker State.

The city lacks many of the hallmarks of a small town in Iowa. Rows of stately buildings and Victorian and Second Empire houses dating back to the mid- to late nineteenth century simply do not exist in Carter Lake. In fact, the community lacks any houses or other edifices dating back to its founding—the result of many factors, including its late incorporation and repeated flooding—unlike other towns in Pottawattamie County.

But that doesn't mean there is a lack of pride in appearance. As Simpson noted in 1960, most of the houses in Carter Lake were in good condition despite a disastrous flood just eight years prior. More than 72 percent of the city's houses were deemed "well preserved or new," and less than 9 percent displayed "deterioration and very poor appearance." Less than 1 percent, totaling six "houses or shacks," were deserted.[286]

Founded with the intent of becoming a blue-collar industrial city, Carter Lake remains just that, although the community's image to passersby has improved greatly in the past five decades. Locust Street, for instance, looks far different than Simpson's observations more than five decades ago, in which he said a visitor "gains only the impression of lowlands, dumps, smoke, smells, beer taverns, service stations, a drive-in movie, two drive-in 'eateries,' a used auto parts yard, and some houses in varying stages of disrepair or dilapidation."[287]

The main drag of Carter Lake has been cleaned up significantly since 1960, a time closer to the town's founding as a throwback to the Wild West of saloons and brothels. Today, those driving from border to border on Locust Street would encounter a couple of gas stations, a bank, a dollar store, a modern city hall building that also houses a police station, a few restaurants, a handful of used car dealerships and auto-repair businesses, a Veterans of Foreign Wars post, a senior center, a fire station, a golf course and a slew of houses on its western edge. There are a few vacant businesses, including two vacated long-term airport parking lots, next to a park on the lakeshore on Carter Lake's easternmost end.

One oddity of Carter Lake's business scene remains the lack of a grocery store. The entirety of the city has been designated a "food desert" by the Economic Research Service of the U.S. Department of Agriculture.[288]

A car heads eastbound along Locust Street in Carter Lake toward Omaha, driving past the Iowa city's welcome sign, showing its borders and namesake lake. *Author photo.*

Under former mayor Russ Kramer, the city commissioned a study and crafted incentives to attract a supermarket—but one has yet to relocate to the city, more than a decade after he began his effort. Instead, residents who desire more than is offered at either of the city's two gas stations or the dollar store are forced to travel into Omaha. "I know we're not big enough for the big monster stores," Kramer told the *Daily Nonpareil* in 2010. "One with a sit-down deli, meat market, pharmacy and a liquor store, maybe a little bakery—that'd be a perfect fit for us."[289]

Though the face of the city has evolved, some of Simpson's observations remain true to this day. On the retail sector, or lack thereof, he noted: "Many of the services considered vital to any community are provided by the neighboring cities. In turn, the general lack of retail outlets in the community means that the Carter Laker must spend his purchasing dollar in other communities than his own."[290] Simpson was no kinder to the Abbott Drive of his era than Locust Street, stating:

> *The traveler passes over in succession a commercial open sewer outlet, an unsightly dock area, the city incinerator plant, an open city refuse sewer, a used and junk car lot, a tank farm (not unsightly), the very*

This undated file photo shows construction of an office building on Owen Parkway Circle along Abbott Drive in Council Bluffs. *Council Bluffs Public Library.*

*unsightly and odorous open city dump, a section of unsightly houses, another dump, some lowlands, and a drive-in restaurant.*[291]

Today, Carter Lake has improved and evolved to where little of Simpson's largely negative views remain intact. Abbott Drive, for instance, is home to Omaha's "string of pearls"—a line of domed streetlights on either side of the road. When not subject to battering by summer hailstorms, which can shatter many and ruin the effect, the roughly three miles to downtown Omaha can be quite scenic. Gone, too, are hallmarks from its intended purpose as an industrial city, such as what one resident who grew up there in the 1920s called "a smaller 'Carter Lake' to the south of Locust Street, which was called 'Oil Lake' because of the waste from the oil industries located under the Locust Street viaduct."[292]

The tank farm is still not unsightly and still exists on Carter Lake's southern edge, but other than a gentleman's club that waffles between being in business and shuttered, the image has greatly improved since 1960. Abbott Drive is home to a collection of hotels, rental car businesses and gas stations, owing to its location so close to Eppley Airfield. Directly across from the airport on the west side of Abbott Drive is the crescent-shaped lake from which the Iowa community takes its name.

An office building on the city's southern edge sits on a circle known as Owen Parkway—named for Owen Industries, the parent company of the steel plant just to the northwest known as Paxton & Vierling Steel, or

*Left*: Rod Kagan stands beside a model of his sculpture unveiled along Abbott Drive in 1987. The fifty-five-foot-tall structure has intentionally rusted over nearly three decades. *From the* Omaha World-Herald/*Rich Janda.*

*Below*: Michael D. Wolff (*right*) takes Beveridge Middle School students Isaac Lopez, Angel Arcos, Morgan Anderson and Elisabeth Weatherly through Paxton & Vierling Steel on October 14, 2014. *From the* Omaha World-Herald/*Rebecca Gratz.*

PVS—right alongside Abbott Drive now houses a truck-leasing business.[293] (The Carter Lake library was renamed in 1991 to honor the company's namesake, Omaha resident and community philanthropist Edward Owen, for his $40,000 grant in 1977 to make the current facility possible.[294] It replaced a dilapidated church annex a volunteer group made into the city's first library in 1968.[295])

Owen Industries' nearly 300,000-square-foot facilities on Avenue H represents the last titan of industry in Carter Lake, as many of the older manufacturing plants have closed up shop or moved.[296] Founded in Omaha in 1885 before moving to Carter Lake in 1939, PVS is the Omaha area's oldest steel company.[297] Those major companies failed to employ many Carter Lake residents, yet the business taxes—which are considered more favorable in Iowa than Nebraska—funded much of the city's maintenance. Simpson noted a now-closed petroleum refinery took over a site with good railroad access and Iowa's favorable tax rates. Although the city lost the industrial plants of its earliest years, Mabrey insisted "enough business operates in Carter Lake to employ every worker in town, 'if that's all they would hire.'"[298]

Iowa representative David Young taps a beam as Tyler Owen, general manager of Paxton and Vierling Steel Company (*left*), leads tours on March 11, 2016. *From the* Daily Nonpareil/*Joe Shearer.*

Once again, enterprising business owners capitalized on the proximity to Omaha and true location in Iowa—and this observation from 1960 remains largely accurate today:

> *Industry in Carter Lake presents a paradoxical picture. It employs only a limited number of residents from the community, yet the residents indirectly derive many benefits from the industries. The existing industry is able to share the favorable tax structure of the State of Iowa, yet it enjoys the proximity of Nebraska within which the majority of its transactions occur. Industry makes little use of the municipal services of Carter Lake, yet it supports through taxation many of these services.*[299]

Among the key services funded by the city's industry is its educational system. Carter Lake opened its first school in 1892 as a part of what is now called the Council Bluffs Community School District, though it never operated its own high school.[300] Instead, the Carter Lake district—which had mostly separated from Council Bluffs in 1929 following Carter Lake's incorporation—approved an agreement that sent the city's high school students to Omaha. When Omaha raised its fees by 25 percent in 1959,

Former Nebraska state senator Lowen Kruse is pictured here speaking about a fourteen-foot totem pole that he installed near Carter Lake Elementary School on October 20, 2015. *From the* Daily Nonpareil*/Joe Shearer.*

Students (*clockwise, from left*) Angie Madsen, Jodi Ives, Randi Coffman, Tim Wright, Shawne Rothmeyer Nelson, Kim Clapper and Lisa Waugh and teacher Linda Nelson attend a legislative breakfast, 1989. *From the* Daily Nonpareil/*Joe Arterburn.*

however, those in ninth grade were then sent to Council Bluffs to attend high school. The Courtland School, first built in 1929, operated as a primary school building at that time.[301]

The Carter Lake school district, like so much of the rest of Carter Lake, Simpson noted, was dependent on other communities to provide the services its residents needed:

> As with so many of the other subsystems in Carter Lake, the school subsystem is unique. It must turn to adjacent communities for secondary education for its children. It is within this subsystem, however, that one finds the most harmonious interaction and unification of efforts by Carter Lake residents to see that the children are provided with opportunities for sound education.[302]

The 1959 agreement was the beginning of the district's affiliation with the Council Bluffs Community School District, into which it merged in 1966. Facing what the Iowa state superintendent of schools, J.C. Wright, called "a unique problem," a new state law passed in 1959 required all rural Iowa school districts to join a district that offered high school classes.[303] (The same measure also effectively dismantled the state's network of one-room schoolhouses in its sparsely populated areas.) Carter Lake was one of four districts that joined Council Bluffs as a result of that mandate by the Iowa legislature.[304]

Iowa governor Terry Branstad laughs with McKayla Cloyd (six) and Chelsea Lawson (seven) during an award celebration on May 1, 1998, at Carter Lake Elementary School. *From the* Omaha World-Herald/*Jeff Bundy.*

Although an elementary school still operates in Carter Lake, it no longer does so at the site of the original Courtland School, having moved to a new spot on Redick Boulevard in 1950.[305] The city's lone school relocated again in 2010 to its present location on Willow Drive after district officials "demolished a 60-year-old school building and replaced it with a two-story, 63,000-square-foot facility."[306] Today, students at Carter Lake Elementary School—save for those who live in one small Council Bluffs apartment complex and have been bused to Carter Lake since Walnut Grove Elementary School closed in 2014—spend fewer years learning in their city of residence than in Council Bluffs.[307] Carter Lake youth attend elementary school between kindergarten and fifth grade at their hometown school. Then, they transition to Council Bluffs in sixth grade, where they attend Woodrow Wilson Middle School for three years before moving on to Thomas Jefferson High School for four more years.

Given the proximity of Carter Lake, the body of water, to the town of the same name, the lake is often a focus of community efforts—even though

Thomas Jefferson High School students and Carter Lake Elementary School teachers perform a flash mob during the 2011 open house for the new elementary school. *From the* Daily Nonpareil/*Cindy Christensen.*

only 18 percent of Carter Lake is actually within the city limits of Carter Lake.[308] Since nearly the instant the lake was formed, residents and officials in both Iowa and Nebraska have debated everything from dredging to water quality to flood control to erosion to fish kills. In its earliest days, though, the lake's water quality was "renowned for its natural beauty, [and] it was said that this lake 'is unsurpassed for its purity and absolute freedom from organic matter.'"[309] Companies cut, removed, stored and sold the lake's water in the winter as ice to keep iceboxes across Omaha and Council Bluffs frigid throughout the year.

But those who love the lake have always battled the river that birthed it to keep the young body of water on life support, even despite the technological and geological advances of nearly 140 years, as rivers often try to reclaim the oxbows they create:

> *From the moment Carter Lake was born, nature launched a relentless campaign to destroy its own creation....For years, it appeared the lake would complete the natural cycle of similar ox-bow lakes, which like humans, and within much the same life span* [sic], *spring into being, flourish briefly,*

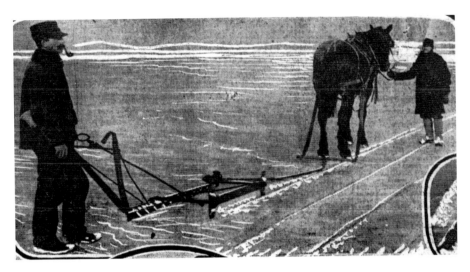

A worker smokes a pipe as a colleague and horse cut lines in the waters of Carter Lake as they harvest ice for Omaha residents, 1916. *From the* Omaha Daily Bee.

*wane and die. Finally man, who early recognized the potential of the lake but was late in realizing its possible fate, decided to fight back.*[310]

Yet the lake lived, unlike the oxbow just to the north known as Lake Florence. Carter Lake and Omaha officials have taken a variety of steps to battle fluctuations in the lake's water levels throughout the years, an ongoing tussle with Mother Nature over rainy years and droughts, in addition to the occasional flood. In 1986, during his second of three nonconsecutive periods as mayor, Waltrip told the *Daily Nonpareil* that the water levels had seen changes year to year ranging as high as eighteen inches or even three feet: "The time is here that we do something with this body of water."[311] But interstate politics scuttled a plan for a pumping system that would draw water from the river when lake levels fell and transport excess water to the river when Carter Lake saw increased water levels—one that became increasingly important after Nebraska officials in 1987 barred the pumping of excess water into Omaha storm sewers for fear it would overload the city's sewage treatment plant.[312]

Pollution from nearby Eppley Airfield in Omaha—which, at the time, emptied storm sewers into eastern portions of the lake and sewer runoff into a lagoon just north of the lake—was responsible for the mass kill of an estimated seventy thousand fish during the winter of 1978, the fourth in the five preceding winters.[313] Yet over the years, other construction around the airport has led to decreased water levels, as land that once

Jack Sparcklin, three, and his father, Kevin Sparcklin, enjoy the view from a walking bridge at Carter Lake on September 18, 2013. *From the* Daily Nonpareil/*Kyle Bruggeman.*

drained to the lake has been diverted to other locations. Elevated carcinogens were reported in fish tissue during a 1988 study by the Nebraska Department of Environmental Control, but it's unclear what caused the spike.[314]

In recent years, the $5 million–plus Carter Lake Restoration Project—funded in part by both the Iowa Department of Natural Resources and Nebraska Game and Parks, among others—has helped improve the lake quality. Beginning between 2004 and 2006, depending on the account, this effort has brought together stakeholders in the two states that have governance over Carter Lake's waters to work toward its betterment. In light of its successes, parties still offer different suggestions on ways to further increase the clarity of Carter Lake against blue-green algae blooms that sometimes crop up in the lake.

The plan's first steps called for the adding of alum to the lake. The chemical binds to phosphorus, a food source for the algae, and the heavier weight of the new compound is designed to "drag to the bottom of the lake, meaning the algae won't have food and will eventually die off."[315] The alum, along with the restocking of fish following killing the fish in the lake with the chemical rotenone—a common compound used to eliminate fish populations that does not harm humans or pets—saw the lake's waters closed to the public for more than three weeks in 2010.[316]

A trumpeter swan stretches its wings while browsing underwater vegetation at Carter Lake on Tuesday, January 14, 2014. *From the* Omaha World-Herald/*Mark Davis.*

Mark Conn steps onto an Aquaris vegetation boat at Carter Lake on August 13, 2013. *From the* Daily Nonpareil/*Kyle Bruggeman.*

An estimated eighty-eight tons of carp and bullhead, bottom-feeding fish whose natural habits make waters murkier rather than clearer, were killed off, replaced by largemouth bass and bluegill in an attempt "to

A single Canada goose glides across the calm waters of Carter Lake. *From the* Daily Nonpareil/*Cindy Christensen.*

create a more natural environment."[317] Other efforts reported on by the *Daily Nonpareil* since then have included the installation of breakwaters and more aquatic plants, dredging, spot vegetation kills, the purchase of a new harvester boat that can haul up to eight tons of vegetation and the suggestion of adding grass carp to the lake, which was later shot down.

"This is really exciting. Clear water gives you a sense of security, a sense of pride," Jeanne Eibes, president of the Carter Lake Preservation Society, told the *Daily Nonpareil* in 2010. "Who wants to get out of the lake and have a green swimsuit? No one. We will be able to see everything (in the water)."[318]

Today, Carter Lake relies on a two-vessel fleet of harvesters to help keep the water as clear as possible. Evidence indicates the recent efforts are working: a 2013 article in the *Daily Nonpareil* noted that Carter Lake's waters were clear to a depth of four or five feet, a dramatic improvement from the six inches to a foot just three years earlier—with a brief spike to eighteen feet during the flood of 2011, which helped feed the lake with clearer groundwater.[319]

"The biggest asset to the entire area," Waltrip said in 1986, would become "an ecological and environmental mess" if it weren't properly maintained.[320]

His dire prediction has yet to come true, although improvements to the lake can still become contentious to this day during the occasional bloom of algae or other unwanted vegetation. More than three decades later, maintenance on the lake remains a high priority—even as leaders in Iowa and Nebraska sometimes still find themselves on opposite sides of the debate on how to improve a lake they share.

# BORN OF CONFUSION, CARTER LAKE SURVIVES AND THRIVES TODAY

To call Carter Lake a bedroom community would be a misstatement, based on its geography. Rather than being geographically separated from the principal cities of its metropolitan area, linked by a highway or road, the city is shoehorned in between Omaha and Council Bluffs. Expanding on the common analogy, it would be more accurate to classify Carter Lake as, say, a hall closet community. In recent years, the city's odd geography has become somewhat of a badge of honor for Carter Lake residents. As noted by the *Daily Nonpareil* in 2004, then-mayor Emil Hausner proudly displayed a bumper sticker that read "Omaha and Council Bluffs: On the outskirts of Carter Lake, Iowa."[321]

Even in 1960, Simpson struggled to find the words to describe Carter Lake and its relationship with its larger neighbors, Omaha and Council Bluffs: "Carter Lake is unique in its very existence. It could well be labeled a parasite city, a dormitory, or a dependent community."[322] Despite its relatively brief history as an incorporated municipality in Iowa, Carter Lake's unique position on Nebraska's side of the river has created its fair share of confusion—and left the city often overlooked by both Omaha and Council Bluffs, Nebraska and Iowa alike.

For most of the community's history, Carter Lake held a Nebraska postal code, meaning its residents needed to obtain their mail at an Omaha post office until as late as 1979, and the city has yet to ever have its own post office—a distinction held by no other town in Iowa.[323] As of 1952, the Omaha post

Among the first customers at Carter Lake's new contract post office in the Carter Lake Press building was Tammy Hintz, who bought a stamp. *From the* Daily Nonpareil.

office serving the Iowa town "scratche[d] out 'Carter Lake, Ia.,' on all village mail and stamp[ed] in 'Omaha, Neb.'"[324] The addressing of envelopes to the Iowa city became even more onerous from there, as the *Daily Nonpareil* reported in 1965: "At the present time, it is necessary for incoming mail to bear the name and address of the receiver as well as the words 'Carter Lake, Iowa, Omaha, Neb.,' plus the Omaha ZIP code."[325] Carter Lake now has a ZIP code all its own: 51510.

Although the community has been served off and on by contract post offices in various locations, it remains somewhat surprising that the second-

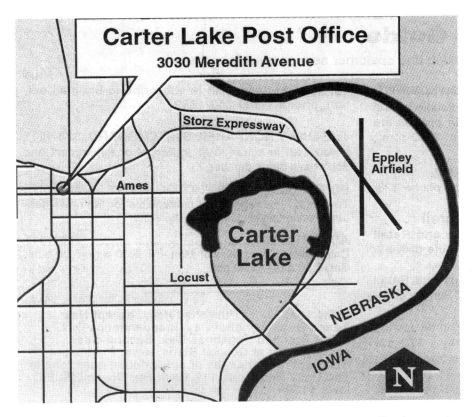

Pottawattamie County's second-largest community has had contract post offices but remains served by a post office in North Omaha. *From the* Daily Nonpareil.

largest city in one of Iowa's ten largest counties does not have a physical post office—something Carter Lake has desired for more than five decades. To this day, it remains served by the Ames Street Post Office in North Omaha, as a "new facility would only be built (for Carter Lake) if service demands could not be met with the existing facility or through expansion."[326] The city's correspondence issues were not just limited to snail mail; some Iowa phone books declined to list Carter Lake phone numbers for many years as well, despite the city's use of the 712 area code serving western Iowa.

Travelers heading from Omaha to Eppley Airfield on Abbott Drive—Iowa Highway 165, the state's shortest at a half-mile in length—encounter "Welcome to Iowa!" signs between them and Nebraska's largest airport. But until those signs were put up in the 1950s, "a lot of motorists passed in and out of Carter Lake without knowing it. It's still possible."[327] Residents essentially shrugged at a "few ruffled Omaha feathers" when the signs were

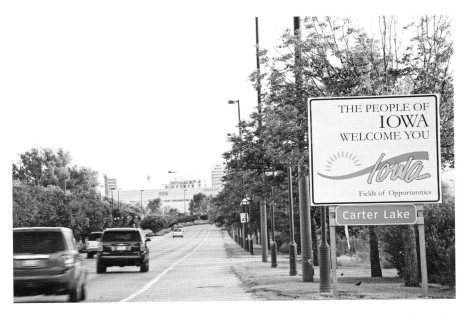

Cars zip from Nebraska to Iowa on Abbott Drive, which becomes Iowa Highway 165 at the point shown beneath the Omaha skyline. *Author photo.*

installed, and Hausner said the dust-up was something the *Omaha World-Herald* "made into a story."[328]

Just across Abbott Drive, property owners on the northeast tip of Carter Lake—now a town of 3,785, according to the 2010 census—pay taxes to two states, as the state line cuts through a handful of backyards that back up to the lake, which is more than three-quarters Nebraska waters. With city and state boundaries around Carter Lake seeming to be more arbitrary than the Missouri's former river channel, having a single property in two states is perhaps the most jaw-dropping geographic oddity left in the community. As Hausner quipped to the *Daily Nonpareil* about his city's strange borders: "If you can figure it out, let me know."[329]

Until 1974, the most convenient interstate exits to reach Carter Lake—which begin on Interstate 29 in Council Bluffs, jump across the Missouri River into Omaha on Interstate 480 and wind north on North Tenth Street until reaching Abbott Drive—weren't even marked until residents petitioned their congressional representative. In a nearly comedic understatement, the *Daily Nonpareil* noted that "[t]he city's location can sometimes be confusing to travelers since it is an Iowa community located on the Nebraska side of the Missouri River.[330]

Pam Elledge feeds ducks, swans, geese and assorted wild birds from her backyard, which backs up to Carter Lake. *From the* Omaha World-Herald/*Rudy Smith.*

In 1979, when the efforts of Representative Tom Harkin and Secretary of Transportation Neil Goldschmidt helped the city get an additional sign on Interstate 480, a reporter remarked in his story that it was "one of the biggest days in Carter Lake history." Though the years of being called Cut-Off Island were long gone, the *Daily Nonpareil* noted how Carter Lake had never really been able to shake its isolation despite being under the shadows of a major city's skyline:

> *For years Carter Lake, Iowa has been a faceless community on the Nebraska side of the Missouri River. Cut off from the rest of the state because of a change in the Missouri River channel, the town of 3,500 has been suffering from an identity crisis.*
>
> *It's bad enough that residents have a Nebraska zip code. It's bad enough that the town is surrounded on all sides by Nebraskans. It's bad enough that Iowans don't give the town a second thought. "Carter Lake? I thought that was in Omaha."*
>
> *But the real kicker was that as one drove across the Interstate 480 Bridge into Omaha, there was no mention of the Iowa burg, just down the road from Eppley Airfield.*[331]

Something as seemingly insignificant to most motorists as a small, green sign placed above a sign on the Dodge Street exit off Interstate 480 had a major psychological boost for Carter Lake residents and officials. By indicating that both Eppley Airfield and a misplaced Iowa community could both be accessed via the thoroughfare below, what was once known as the "forgotten city" was now acknowledged.

Carter Lake officials interviewed by the newspaper were effusive in their praise, equal parts glad and relieved that federal officials had thought to give their city the recognition they so often missed by being sandwiched between two states and larger cities while rarely being given the time of day by either. "It's something wonderful for Carter Lake," Mary Marfisi told the *Daily Nonpareil.* "There's not much done for us." After years of wanting "someone to know that they were over there, nestled in the Missouri River floodplain," the pleas that had for years fallen on deaf ears were answered.[332]

That, however, appears to be the exception rather than the rule.

When speaking to the *Des Moines Register* in 1988, Mayor Gerald Waltrip likened the community to "an abandoned child that has been sitting on Iowa's back porch for more than 100 years, just waiting for somebody to open the door." The mayor then quipped: "I've had some of those people tell me my problem is that you're 'over there.' But when I pay my Iowa taxes nobody ever says, 'We don't want it; it's from over there.'"[333]

The U.S. Census Bureau sent forms for the decennial 1990 census to Carter Lake. But there was a glaring error as far as residents were concerned: The documents listed the city of residence of the recipient as Omaha. Mayor Gerald Waltrip told the *Daily Nonpareil* that he encouraged residents not to return the forms as requested over fear they would be counted wrong: "They screwed it up, and they can just unscrew it."[334] In an attempt to allay the fears of Waltrip and his city, the Census Bureau assured that the practice was common and that a review of information gathered would be given to the mayor's office.

Furthermore, a geocode on the form would ensure that Carter Lake residents' information would, in fact, be counted in Sioux City as a part of Iowa. Whether John Dale—assistant manager for the Census Bureau's office in Kansas City, Missouri, at the time—knew the history of the community about which he was speaking when he talked to the Council Bluffs newspaper is unclear. But he hit the nail on the head with his analysis: "This situation is not unique to Carter Lake. They are just more cognizant of it."[335]

Because of the near-permanent state of flux in which Carter Lake residents found themselves, many are particularly sensitive to geography. Echoing

*Above*: The Carter Lake eagle—part of the "Eagles of Honor" effort for veterans' monuments in every Pottawattamie County community—sits outside city hall. *Author photo.*

*Right*: The logo on the glass held by Doug Johnson, used by First Bank and Trust of Carter Lake, was selected as the city's official symbol. *From the* Daily Nonpareil.

the words of Wilson Mabrey long after his death, these people are Iowans, and many moved to Carter Lake because that is exactly what they wished to be—no matter how many geography lessons they have to give family, friends, co-workers and acquaintances. Despite their efforts, residents of this small town in the city found themselves dealing with preconceived notions about their town, many of which are now incorrect but have lingered since even before Simpson's survey of the community.

> *The unique geographical location of the community and the resultant state boundary disputes contributed to the setting aside of this community from other typical middle western communities. It is to be noted that the typical Carter Lake resident exhibited marked feelings of inferiority concerning the image of his community in the eyes of residents of Omaha and Council Bluffs. He felt, and rightly so, that the residents of Omaha and Council Bluffs looked down upon him and his community. To be a Carter Laker was an admission of personal and social inadequacy. This feeling of inadequacy influenced community interaction and participation.[336]*

Even in 1994, when the Pottawattamie County Board of Supervisors deeded trusteeship of two thousand feet of riverfront from the long-forgotten East Omaha Drainage District, it kicked up a brief firestorm that drew Iowa and Nebraska's governors to the microphone to defend the state. A former park, opened in 1988 but soon closed because of vandalism, had been operated by the Pottawattamie County Conservation Board on the west bank of the riverfront in what was presumed to be Carter Lake. Both times, Omaha fought back and claimed the land was its own, with lawyers from both states arguing about deeds and a U.S. Supreme Court ruling from more than a century prior. Omaha claimed the property had been deeded to a body it absorbed through growth, while a Council Bluffs attorney who worked the issue both times "stated the word 'Iowa' was written on the deed, further establishing the district as Iowa's."[337]

The land remains part of Carter Lake to this day, maintaining its purpose, in the words of then-mayor Bill Blankenship, of making "Carter Lake a peninsula and not an island."[338] Although this appears to be the most recent border spat, long into the future, debate between the states will still likely bubble up from time to time. Though the statehood of Carter Lake has truly been put to bed since 1877, as the city has never been part of Nebraska, questions will inevitably rise again. But, unlike so often in its earliest days, Carter Lake seems quite content with its current location. A popular bumper

Steve Brown of Carter Lake (*left*) and his nine-year-old son, Nicholas, check out a motorcycle during the Carter Lake Community Day on June 4, 2016. *From the* Daily Nonpareil/*Joe Shearer.*

sticker in the city reads "Carter Lake: A slice of heaven in Nebraska." After all, as a local historian noted, "Carter Lake is not really Nebraska, and it's not really Iowa. It's a bit of a mystery that may defy solution."[339]

As was asked earlier, what is Carter Lake? Today, it is a community that still defends its Iowa roots. It is a 315-acre oxbow lake, one that draws an estimated forty-seven thousand people per year, that surrounds on three sides a vibrant town of the same name.[340] It's a city that offers plenty of outdoor options to residents and visitors alike, with a golf course, parks and, of course, lake access. It's a small town without a true downtown—yet its residents live, work and play within sight of another state's skyline. It's a community that has both its blue-collar and high-society elements and draws both to celebrate its civic pride, despite occasionally being the misplaced butt of local jokes, at an annual parade that features a variety of community and student groups.

At its most recent mayoral election in 2013, poll workers handed out free T-shirts that read "Carter Lake—Pride Inside." Today, Carter Lake routinely draws voter participation that would make most cities jealous. In its most recent mayoral election in 2013, the city's two wards saw a voter turnout of 39.47 percent—nearly 250 percent higher than Council

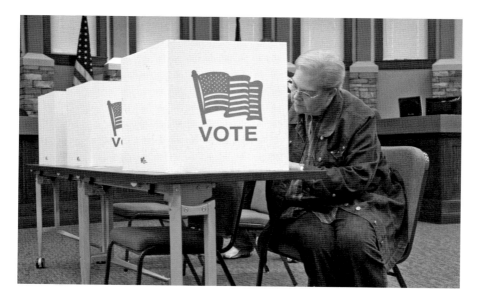

Rhonda Hanking is pictured here voting at Carter Lake City Hall for municipal elections on the morning of November 5, 2013. *From the* Daily Nonpareil/*John Schreier.*

Bluffs in a year that saw competitive mayoral and city council races in both cities.[341]

Historically speaking, the city almost always leads Pottawattamie County in the percentage of eligible voters who cast ballots. One thing remains certain: By and large, Carter Lake residents remain very passionate about having a say in their government, dating all the way back to Wilson Mabrey's first election. The cause of this may very well be rooted in the well-documented fact that the city's elected officials stood up for residents' wishes when county, metro area and state officials would not do the same.

Despite its past as a haven for vice, many residents of Carter Lake revel in their little lakeside oasis. Many of the residents moved from Omaha or Council Bluffs to live on a lake, in a small town—or both—within sight of the big city. In that way, the original allure of Courtland Beach remains true more than a century later. One example of that is Mavis Malstead, who along with her late husband, Vern, turned their summer cabin on the lakeshore into their permanent home and fell in love with the town. In a 2004 interview with the *Daily Nonpareil*, she recalled her husband always said, "One of these days, people are going to discover Carter Lake."[342]

As Carter Lake native Wanda Rosenbaugh told the *Omaha World-Herald* in 1997: "We've had a few nightspots that have had trouble from time to time.

A man stands on Carter Lake's eastern shore in Nebraska and looks out as Omaha's skyline towers over both the lake and Iowa city. *Author photo.*

But it's a lovely place with a lakeside you can walk to. We're close to the airport. We're close to downtown Omaha."[343]

The Reverend Art Matychuk, pastor of Lakeside Bible Church, was mostly correct when he was interviewed by the *New York Times* in 1988: "I think Carter Lake, quite frankly, is changing its image. Five years from now, there will be only a few old people who will still talk about the bad old days."[344] The old community for hustlers, gamblers and card sharks is certainly long gone. Indeed, the pastor's remarks are most definitely true, and the city has been on the rise nearly the entire time since its incorporation in 1930. But the odd geography that birthed Carter Lake's role for both family pleasure and vice in the shadows will forever remain with the town.

So, too, will its independent streak and desire to remain in Iowa. The Missouri River appears to be firmly in its channel, despite the occasional flood, and the state line remains fixed with it. The boundary, rather than going straight down the middle of the channel as was so frequently proposed, makes one crescent-shaped exception—and there resides Carter Lake. The only threat to its statehood in Iowa was Nebraska lawmakers, and even they appear to be resigned to the fate of never being able to claim it for Omaha.

No longer is Carter Lake cut off and isolated between the metropolitan area's principal cities of Omaha and Council Bluffs. Rather, the land once called "Cut-Off Island" now finds itself in the middle of everything—with both Omaha and Council Bluffs on its outskirts, as a bumper sticker on its former mayor's car proclaimed. The story of Carter Lake is not one that makes a simple, straight line; it's been a complex path with plenty of unexpected twists and turns, much like the river that birthed it. Now, the community enjoys the small, horseshoe-shaped niche it has forged out of the uncertainty between its roots in Iowa and constant geographical pull toward Nebraska.

# NOTES

## INTRODUCTION

1. "Fight Over Carter Lake," *Omaha World-Herald*, July 8, 1934.
2. Harding, "Meandering River Created Kerfuffle."
3. Carter Lake Environmental Assessment and Rehabilitation Council, "Carter Lake Water Quality Management Plan," May 2008.
4. "Avulsion," Tropospheric Aerosol Library.
5. Robbins, "CARTER LAKE JOURNAL; Standing by a Capricious Neighbor."
6. Simpson, *River Town*, 115.
7. Parrott, "Electorate of Carter Lake Should Settle Boundary Row."
8. Parrott, "Carter Lake Residents Take Lots of Pride in Their Town—Over There."
9. Simpson, *River Town*, 14–15.
10. Fruhling, "Iowa's Town 'Over There' Suffers under Identity Crisis."
11. Offenburger, "Mayor Ending Colorful Career at Carter Lake."
12. "Swimmers Try Out Carter Lake Water," *Omaha Daily Bee*, April 20, 1915, http://nebnewspapers.unl.edu/lccn/sn99021999/1915-04-20/ed-1/seq-5/.
13. McMahon, "Greetings from Carter Lake."
14. Parrott, "Carter Lake Residents Take Lots of Pride in Their Town—Over There."
15. "Carter Lake Wants to Remain in Iowa—Not Be Given to Nebraska," *Daily Nonpareil*, December 13, 1957.
16. Simpson, *River Town*, 6.

# Chapter 1

17. Faris, "Dr. Jefferis Turned to Herbs to Treat C.B. People."
18. *Omaha Daily Bee*, January 24, 1885. http://nebnewspapers.unl.edu/lccn/sn99021999/1885-01-24/ed-1/seq-6/.
19. Faris, "Dr. Jefferis Turned to Herbs to Treat C.B. People."
20. Faris, "The Good Doctor Made Booze, Too."
21. McGinn, "Home Owned by Dr. Jefferis—an Early Bluffs Settler."
22. Preserve Council Bluffs, "523 Sixth Avenue—Thomas Jefferis."
23. Faris, "Jefferis Mill City's Cause for Celebration."
24. Simpson, *River Town*, 21.
25. "Death of a Pioneer," *Daily Nonpareil*, January 8, 1895.
26. "Small Town by a Roaming River," *Daily Nonpareil*, October 3, 1976.
27. "Death of a Pioneer."
28. Field and Reed, *History of Pottawattamie County*, 91.
29. "Judge Brewer Renders an Opinion Regarding Accretion Rights on Cut-Off Island," *Daily Nonpareil*, December 14, 1889.
30. "Death of a Pioneer."
31. Ibid.

# Chapter 2

32. Sylvester, "Omaha's Flood, 1952."
33. Nell and Demetriades, "True Utmost Reaches of the Missouri River."
34. Pinter and Heine, "Hydrologic History of the Lower Missouri River."
35. New World Encyclopedia contributors, "Missouri River."
36. Pinter and Heine, "Hydrologic History of the Lower Missouri River," 3.
37. "Fight Over Carter Lake."
38. "When the Big Muddy Gets Out of Its Banks," *Omaha Daily Bee*, July 16, 1905, http://nebnewspapers.unl.edu/lccn/sn99021999/1905-07-16/ed-1/seq-21/.
39. "Fight Over Carter Lake."
40. Allin, "'Thousand and One Little Delays': Training the Missouri River at Omaha, 1877–1883."
41. Pinter and Heine, "Hydrologic History of the Lower Missouri River," 3.
42. Boyce, "Carter Lake."
43. Allin, "Thousand and One Little Delays," 351.
44. Ehrlich, "Problems Arising from Shifts of the Missouri River on the Eastern Border of Nebraska."

45. "Today, Tomorrow, All Summer: Courtland Beach Will Be Open to the Public," *Omaha Daily Bee*, June 18, 1893. http://nebnewspapers.unl.edu/lccn/sn99021999/1893-06-18/ed-1/seq-17/.

46. Larsen et al., *Upstream Metropolis: An Urban Biography of Omaha and Council Bluffs*, 7.

47. "Freaks of the Missouri," *New York Times*, November 15, 1901.

48. National Weather Service, "Historic Crests."

49. Nell and Demetriades, "True Utmost Reaches of the Missouri River."

50. "When the Big Muddy Gets Out of Its Banks," *Omaha Daily Bee*, July 16, 1905, 21.

51. Simpson, *River Town*, 20.

# CHAPTER 3

52. Parrott, "Electorate of Carter Lake Should Settle Boundary Row."

53. "Freaks of the Missouri."

54. Smith Camp, "Land Accretion and Avulsion: The Battle of Blackbird Bend."

55. "Judge Brewer Renders an Opinion Regarding Accretion Rights on Cut-Off Island," 3.

56. "Fight Over Carter Lake."

57. "Avulsion," Tropospheric Aerosol Library.

58. "Status of Carter Lake Shouldn't Be Left Out," *Omaha World-Herald*, September 10, 1989.

59. Ehrlich, "Problems Arising from Shifts of the Missouri River," 343.

60. "Status of Carter Lake Shouldn't Be Left Out."

61. Tobias, "'On the Wrong Side of the River': The Odd Story of McKissick Island, Nebraska."

62. *Missouri v. Nebraska*, 196 U.S. 23 (1904).

63. Ehrlich, "Problems Arising from Shifts of the Missouri River," 353.

64. Ibid.

65. "Avulsion," Tropospheric Aerosol Library.

66. *Nebraska v. Iowa*, 406 U.S. 19 (1972).

67. "Freaks of the Missouri."

# Chapter 4

68. "Levi Carter Pioneer Capitalist and Philanthropist," *Omaha Daily Bee*, July 19, 1908: 19–20, http://nebnewspapers.unl.edu/lccn/sn99021999/1908-07-19/ed-1/seq-19/.

69. Andreas, *History of the State of Nebraska*.

70. "Levi Carter Pioneer Capitalist and Philanthropist."

71. Fletcher Sasse, "Short History of the Original East Omaha."

72. Environmental Protection Agency, "Removal Activities to Begin, Former Carter White Lead Superfund Site, Omaha, Douglas County, Nebraska."

73. Andreas, *History of the State of Nebraska*.

74. Simpson, *River Town*, 71–72.

75. *Daily Nonpareil*, November 8, 1903.

76. "Levi Carter Pioneer Capitalist and Philanthropist."

77. Nebraska State Historical Society, "Carter White Lead Company (Omaha, Neb.)."

78. Harvard Business School, "National Lead Company."

79. Fogarty and Mumgaard, "Omaha's Gambling History."

80. "Cut-Off Island to be Left Without Police Protection," *Omaha Daily Bee*, February 2, 1891, http://nebnewspapers.unl.edu/lccn/sn99021999/1891-02-02/ed-1/seq-3/.

81. Janovy, "Taking Off the Tarnish."

82. *Daily Nonpareil*, November 8, 1903, 6.

83. Fletcher Sasse, "Short History of the Original East Omaha."

84. "Omaha Parks and Boulevards Source of Civic Pride." *Omaha Daily Bee*, April 11, 1909. http://nebnewspapers.unl.edu/lccn/sn99021999/1909-04-11/ed-1/seq-17/.

85. Janovy, "Taking Off the Tarnish."

86. "Donates Big Park to Omaha," *Daily Nonpareil*, July 16, 1908.

87. "Levi Carter Pioneer Capitalist and Philanthropist."

# Chapter 5

88. Fletcher Sasse, "Short History of the Original East Omaha."

89. Ibid.

90. Simpson, *River Town*, 22.

91. Ibid., 23.

92. Ibid., 24–25.

93. Fletcher Sasse, "Early History of Omaha's Carter Lake, aka Lake Nakoma, aka Cutoff Lake."

94. Larsen et al., *Upstream Metropolis*, 119.

95. Harding, "Meandering River Creates Kerfuffle."

96. "East Omaha Moves for Secession," *Omaha Daily Bee*, January 9, 1926.

97. "Carter Lake May Go to Omaha by Commission Act," *Omaha World-Herald*, January 9, 1926.

98. "East Omaha Moves for Secession."

99. "East Omaha May Secede from Iowa," *Omaha Daily Bee*, December 21, 1925.

100. "East Omaha Moves for Secession."

101. Simpson, *River Town*, 29.

102. Ibid., 32.

103. "Nebraskans Plan Fight for E. Omaha," *Omaha Daily Bee*, December 20, 1925.

104. Simpson, *River Town*, 33.

105. "Nebraskans Plan Fight for E. Omaha."

106. "'Secession' Move Appears Plan to Join Omaha," *Omaha World-Herald*, March 3, 1926.

107. Ibid.

108. "East Omaha Wins 'Divorce' Suit," *Daily Nonpareil*, September 30, 1928.

109. "East Omaha Gets Its Final Decree," *Daily Nonpareil*, June 20, 1929.

110. "Carter Lake Voters Once Sought Switch," *Omaha World-Herald*, April 17, 1960.

111. Simpson, *River Town*, 109.

112. "Carter Lake Residents Will Select Iowa at Boundary Hearing Sept. 17," *Daily Nonpareil*, September 1, 1960.

# CHAPTER 6

113. "Plan East Omaha Incorporation Soon," *Daily Nonpareil*, June 3, 1930.

114. "Carter Lake to Vote on Forming New Town," *Omaha World-Herald*, June 1, 1930.

115. Iowa Secretary of State's Office, "Incorporated Cities."

116. "Carter Lake Votes on Town Officials," *Daily Nonpareil*, July 2, 1930.

117. "'Progressives' at Carter Lake Win," *Daily Nonpareil*, July 3, 1930.

118. "'Carter Lake May Pave," *Daily Nonpareil*, July 30, 1930.

119. Patton, "Mabrey Ready to Step out of Office—In Four Years."

120. Boyer, "Whatever You Call Him, Mabrey Gets Action."

121. Ibid.

122. "'Progressives' at Carter Lake Win."

123. Offenburger, "Mayor Ending Colorful Career at Carter Lake."

124. Simpson, *River Town*, 35.

125. Boyer, "Whatever You Call Him, Mabrey Gets Action."

126. Patton, "Mabrey Ready to Step out of Office."

127. Boyer, "Whatever You Call Him, Mabrey Gets Action."

128. Patton, "Mabrey Ready to Step out of Office."

129. Offenburger, "Mayor Ending Colorful Career at Carter Lake."

130. "Carter Lake Mayor Faces Charge in Road Grader Case," *Daily Nonpareil*, November 1, 1965.

131. Patton, "Mabrey Ready to Step out of Office."

132. "Mabrey Is Found Innocent," *Daily Nonpareil*, December 21, 1965.

133. Patton, "Mabrey Ready to Step out of Office."

134. Offenburger, "Mayor Ending Colorful Career at Carter Lake."

135. Peterson, "Mabrey Recalls Carter Lake's Early History."

136. Offenburger, "Mayor Ending Colorful Career at Carter Lake."

137. Kaufman, "Waltrip Ousts Kramer as Carter Lake Mayor."

138. Offenburger, "Mayor Ending Colorful Career at Carter Lake."

139. "Former C.L. Mayor Dead at 75," *Daily Nonpareil*, October 30, 1977.

140. Offenburger, "Mayor Ending Colorful Career at Carter Lake."

141. Peterson, "Mabrey Recalls Carter Lake's Early History."

142. Boyer, "Whatever You Call Him, Mabrey Gets Action."

143. Ibid.

# CHAPTER 7

144. Harding, "Meandering River Created Kerfuffle."

145. "Courtland Beach and Manawa," *Omaha Daily Bee*, May 29, 1902.

146. "Cool 4th at Courtland Beach," *Omaha Sun*, July 6, 1978.

147. Fletcher Sasse, "Early History of Omaha's Carter Lake, aka Lake Nakoma, aka Cutoff Lake."

148. *Omaha Daily Bee*, June 27, 1894, http://nebnewspapers.unl.edu/lccn/sn99021999/1894-06-27/ed-1/seq-8/.

149. "Swimmers Try Out Carter Lake Water," *Omaha Daily Bee*, April 20, 1915.

150. Fletecher Sasse, "Early History of Omaha's Carter Lake, aka Lake Nakoma, aka Cutoff Lake."

151. Ibid.

152. "Three Thousand Fish Are Placed in Carter Lake." *Omaha Daily Bee*, October 29, 1910. http://nebnewspapers.unl.edu/lccn/sn99021999/1910-10-29/ed-1/seq-5/.

153. "Cool 4th at Courtland Beach."

154. McKee, "Jim McKee: Lake Manawa, Nebraska or Iowa?"

155. "Iowa State Parks & Recreation Areas: 2011 Annual Report Supplement."

156. "Courtland Beach and Manawa," *Omaha Daily Bee*, May 29, 1902.

157. "Carter Lake Development Hinges on Land Ownership," *Daily Nonpareil*, November 4, 1947.

158. "Carter Lake and Omaha Must Iron Out Own Land Problems," *Daily Nonpareil*, November 11, 1947.

159. Fletcher Sasse, "History of Omaha's Pleasure Pier and Kiddieland."

160. "Cool 4th at Courtland Beach."

161. Harding, "Meandering River Created Kerfuffle."

162. Schreier, "Carter Lake's Colorful, Confusing History."

163. "Tramp on No Man's Land: How Cut-Off Island Is Reached and Bounded," *Omaha Daily Bee*, May 19, 1889, http://nebnewspapers.unl.edu/lccn/sn99021999/1889-05-19/ed-1/seq-21/.

164. Simpson, *River Town*, 28.

165. "Carter Lake to Be Oasis for Omaha with 16 Permits," *Omaha World-Herald*, April 20, 1933.

166. "Carter Lake Drive to End Gaming Era," *Des Moines Register*, January 10, 1954.

167. "No Gambling in Omaha," *New York Times*, July 4, 1889, http://query.nytimes.com/mem/archive-free/pdf?res=9504E4DF1430E633A25757C0A9619C94669FD7CF.

168. Beerman, "History of the Mafia in Omaha."

169. Kelly, "Nephew Recalls 'Nebraska's First Lady of the Mob.'"

170. "No Gambling in Omaha."

171. Robbins, "Carter Lake Journal; Standing by a Capricious Neighbor."

172. Fogarty and Mumgaard, "Omaha's Gambling History."

173. Kelly, "Nephew Recalls 'Nebraska's First Lady of the Mob.'"

174. Boyer, "Whatever You Call Him, Mabrey Gets Action."

175. Janovy, "Taking Off the Tarnish," 1.

176. Beerman, "History of the Mafia in Omaha."

177. Parrott, "Carter Lake Residents Take Lots of Pride in Their Town—Over There."

178. Peterson, "Mabrey Recalls Carter Lake's Early History."

179. "Carter Lake Drive to End Gaming Era."

180. Patton, "Mabrey Ready to Step out of Office."

181. "Carter Lake OKs Casino Site," *Daily Nonpareil*, April 14, 1994.

182. Peterson, "Carter Lake Sues Omaha Over Casino."

183. Anderson, "Carter Lake Presses Its Casino Case."

184. Stoltzfus, "Cities Reach Land Agreement."

185. Stoltzfus, "Decision Dashes Dreams."

186. White, "Long Ride Home for Carter Lake Backers."

187. Rohwer, "C.L. Council Approves Resolution about Casino Possibility."

188. Associated Press, "Ponca Tribe Mulling Carter Lake Casino," *Indian Country News*, January 28, 2008. http://www.indiancountrynews.com/index.php/news/politcs-business/2428-ponca-tribe-mulling-carter-lake-casino.

189. Nation, "Miller Files Lawsuit over Gaming Legality."

190. Ibid.

191. Nation, "County 'Supports' Suit Against Casino."

192. Abourezk, "For Tribes, Business an Emerging Battleground."

193. Thomas, "Carter Lake Expects Community to Bloom."

# CHAPTER 8

194. "Tramp on No Man's Land: How Cut-Off Island Is Reached and Bounded," *Omaha Daily Bee*, May 19, 1889

195. "Historic Floods on the Missouri River: Fighting the Big Muddy in Nebraska."

196. Ibid.

197. McKee, "Jim McKee: Missouri River Has a Storied History of Flooding."

198. "Historic Floods on the Missouri River."

199. "Flood Waters Break Omaha Levee: Carter Lake and Airport Are Periled," *Des Moines Register*, April 13, 1943.

200. National Weather Service, "Historic Crests."

201. "Historic Floods on the Missouri River."

202. Simpson, *River Town*, 68–69.

203. Holbrook, "Historic Floods of the Big Muddy."

204. Friend, "Missouri River Has Done This Before."
205. Sylvester, "Omaha's Flood, 1952," 45.
206. National Weather Service, "Historic Crests."
207. "Historic Floods on the Missouri River."
208. Sylvester, "Omaha's Flood, 1952," 51.
209. Leu, "New Leader Under Pressure."
210. Sylvester, "Omaha's Flood, 1952," 54.
211. McKee, "Missouri River Has a Storied History of Flooding."
212. Sylvester, "Omaha's Flood, 1952," 55.
213. McKee, "Missouri River Has a Storied History of Flooding."
214. Brownlee, "FLOOD: Carter Lake Has Sandbags Ready to Go."
215. Simpson, *River Town*, 75.
216. "Fire Department 'Like a Phoenix,'" *Daily Nonpareil*, October 3, 1976.
217. Fahrenkrug, "Carter Lake Fire Department Seeks Funds for Replacement."
218. Kaufman, "Balancing Work and Family Part of a Volunteer Firefighter's Job."
219. Kaufman, "Carter Lake Fire Department Concerned with Accommodations, Equipment."
220. Kaufman, "Water Rescue Are Services 'Essential' to Carter Lake."
221. "Omaha News," *Daily Nonpareil*, October 4, 1889.
222. Coulton, "Carter Lake Keeps Police Reserve Unit."
223. Hendricks, "Carter Lake Seeks Law Aid from Pott. County."
224. "C.L. Keeps Law in Its Own Hands," *Daily Nonpareil*, February 12, 1980.
225. Rosenberg, "Grand Jury Criticizes Carter Lake Government."
226. "Carter Lake Tops State Crime List," *Daily Nonpareil*, January 17, 1992.
227. Arterburn, "Carter Lake Chief: Geography Is Cause of High Crime Rate."
228. Peterson, "Carter Lake Says Crime Figures Show Town Safe."
229. Simpson, *River Town*, 75.

# CHAPTER 9

230. Simpson, *River Town*, 109.
231. Patton, "They're Migrating Fast to Carter Lake, IOWA."
232. "Baird Tells of Legislature's Work," *Daily Nonpareil*, November 28, 1923.
233. Groneweg, Crowley and Walling, "Iowa Boundary Commission to the Hon. John Hamill, Governor of Iowa."

234. "Carter Lake May Go to Omaha by Commission Act," *Omaha World-Herald*, January 9, 1926.

235. "East Omaha Moves for Secession."

236. Smetana, *History of Lake Manawa 1881–1981*, 161.

237. McKee, "Lake Manawa, Nebraska or Iowa?"

238. "Carter Lake to Oppose Change." *Daily Nonpareil*, February 23, 1941.

239. "'It's Pipe Dream,' Omaha Taking C.B.," *Daily Nonpareil*, December 18, 1925.

240. Smith Camp, "Land Accretion and Avulsion: The Battle of Blackbird Bend," 822.

241. Parrott, "Electorate of Carter Lake Should Settle Boundary Row."

242. Smith Camp, "Land Accretion and Avulsion: The Battle of Blackbird Bend," 822.

243. "Nebraska Senator Is Given Lesson in State Geography," *Daily Nonpareil*, January 3, 1947.

244. Ibid.

245. "Here's Answer for Professor on Carter Lake's Situation," *Daily Nonpareil*, August 10, 1947.

246. Parrott, "Electorate of Carter Lake Should Settle Boundary Row."

247. "Carter Lake Residents Wish to Remain in Iowa," *Daily Nonpareil*, April 14, 1960.

248. Parrott, "Carter Lake Residents Take Lots of Pride in Their Town—Over There."

249. "Carter Lake Wants to Remain in Iowa—Not Be Given to Nebraska," *Daily Nonpareil*, December 13, 1957.

250. "Carter Lake Part of City," *Omaha World-Herald*, April 13, 1960.

251. "Mabrey Rips into Nebraska," *Daily Nonpareil*, April 13, 1960.

252. "Carter Lake Residents Will Select Iowa at Boundary Hearing Sept. 17."

253. "Omahan Threatens to Boycott Boundary Hearing at Carter Lake," *Daily Nonpareil*, September 2, 1960.

254. "Loud, Clear and Unanimous: Carter Lake People Pick Iowa," *Daily Nonpareil*, September 18, 1960.

255. Patton, "'Sold Down the River,' Carter Lake Opinion."

256. Shotwell, "Carter Lake Seeks Pledge That It'll Always Be in Iowa."

257. Patton, "Sold Down the River."

258. "County Support to Carter Lake," *Daily Nonpareil*, December 22, 1960.

259. "Rep. Lisle Astonished by Pleas to Keep Carter Lake on Iowa," *Daily Nonpareil*, January 20, 1961.

260. Shotwell, "Carter Lake Seeks Pledge That It'll Always Be in Iowa."

261. Stokes, "House Votes to Keep Carter Lake in Iowa."

262. "Omahans Denounce Iowa Action on Boundary Bill," *Daily Nonpareil*, April 12, 1961.

263. Stokes, "House Votes to Keep Carter Lake in Iowa."

264. "Should Settle Boundary Dispute with Nebraska," *Daily Nonpareil*, February 7, 1963.

265. "Carter Lake Boundary Move Gets Cold Reception," *Daily Nonpareil*, February 5, 1963.

266. "Carter Lake Residents Ask to Be 'Left Alone,'" *Daily Nonpareil*, May 8, 1964.

267. Zimmerman, "Iowa Denies Violations of '43 River Compact."

268. Janson, "Iowa Is Called Aggressor State."

269. "Appoint Special Master in Iowa-Nebraska Dispute," *Daily Nonpareil*, February 1, 1965.

270. Kotz, "High Court Hears Iowa Border Case."

271. "Iowa-Nebraska Border Issues," *Des Moines Register*, October 3, 1965.

272. Van Nostrand, "Cession of Carter Lake Not Solving Problem."

273. "Iowa-Nebraska Border Issues."

274. Simpson, *River Town*, 112.

275. Patton, "Carter Lake Makes Move to Remain Part of Iowa."

276. Offenburger, "Mayor Ending Colorful Career at Carter Lake."

277. Boyer, "Whatever You Call Him, Mabrey Gets Action."

278. *Nebraska v. Iowa*, 406 U.S. 19 (1972).

279. Arterburn, "Iowa Panel Won't 'Swap' Carter Lake."

280. Parrott, "Electorate of Carter Lake Should Settle Boundary Row."

281. Boyer, "Whatever You Call Him, Mabrey Gets Action."

# CHAPTER 10

282. Patton, "They're Migrating Fast to Carter Lake, IOWA."

283. Simpson, *River Town*, 38.

284. Ibid., 44.

285. Ibid., 20.

286. Ibid., 17.

287. Ibid., 14.

288. Economic Research Service of the U.S. Department of Agriculture, "Food Access Research Atlas."

289. Brownlee, "Mayor Pushes for Grocery Store."

290. Simpson, *River Town*, 79.

291. Ibid., 15.

292. May Nielsen Lauritsen journal, "Recollections of East Omaha Dairies in the 20's," Council Bluffs Public Library Special Collections.

293. Rohwer, "Omaha Company Ready to Finalize Carter Lake Location."

294. Andersen, "C.L. Library Is Renamed to Honor Edward Owen."

295. Lehmer, "Carter Lake Library Moves to New Big 'Sagging' Home."

296. Owen Industries, "Same Company, Fresh New Look," September 21, 2015.

297. "Steel Plant in 75th Year," *Omaha World-Herald*, September 2, 1960.

298. Parrott, "Carter Lake Residents Take Lots of Pride in Their Town—Over There."

299. Simpson, *River Town*, 71.

300. Friend, "What Happened to the Buildings?"

301. Council Bluffs Community School District, "History of the Council Bluffs Community School District."

302. Simpson, *River Town*, 85.

303. "Carter Lake Students Must Go to Iowa High," *Omaha World-Herald*, March 22, 1959.

304. Council Bluffs Community School District, "History of the Council Bluffs Community School District."

305. Friend, "What Happened to the Buildings?"

306. Friend, "School's in Session."

307. Coffey, "CBCSD Discusses Proposed Attendance Area for Walnut Grove Students."

308. McMahon, "On the Outskirts of Carter Lake, Iowa."

309. Fletcher Sasse, "Early History of Omaha's Carter Lake, aka Lake Nakoma, aka Cutoff Lake."

310. Boughn, "Man Fights Attraction."

311. Taylor, "Officials Hope $840,000 Pipeline Will Stop Carter Lake Fluctuations."

312. Fruhling, "Iowa's Town 'Over There' Suffers under Identity Crisis."

313. "Airport Partly to Blame for Fish Kills: DEQ," *Daily Nonpareil*, December 8, 1979.

314. Arterburn, "No Warnings for C.L. Tainted Fish."

315. Brownlee, "Saving Carter Lake."

316. Brownlee, "Lake Closed This Week."

317. Kaufman, "DNR Says Grass Carp Won't Help Carter Lake Algae."

318. Brownlee, "Saving Carter Lake."

319. Kaufman, "DNR: 'No Easy Solution' for Carter Lake."

320. Taylor, "Officials Hope $840,000 Pipeline Will Stop Carter Lake Fluctuations."

## Conclusion

321. McMahon, "On the Outskirts of Carter Lake, Iowa."

322. Simpson, *River Town*, 4–5.

323. Patton, "City Now in Step with Post Office."

324. Koffend, "Suit over 140 Acres Could Affect Development of Lake."

325. Patton, "C.L. Wants More Than Stamp Store."

326. Peterson, "Carter Lake Not Likely to Get Own Post Office."

327. Parrott, "Carter Lake Residents Take Lots of Pride in Their Town— Over There."

328. McMahon, "Greetings from Carter Lake."

329. Ibid.

330. "Signs Planned for Travelers to Carter Lake." *Daily Nonpareil*, August 29, 1974.

331. Hendricks, "Carter Lake Sign Gives City Its Own Identity."

332. Ibid.

333. Fruhling, "Iowa's Town 'Over There' Suffers Under Identity Crisis."

334. McAndrews, "Iowa Loses Carter Lake in U.S. Census Forms."

335. Ibid.

336. Simpson, *River Town*, 115-116.

337. Peterson, "Omaha's Claim Is Nothing New."

338. Peterson, "Board Turns Area Over to Carter Lake."

339. Harding, "Meandering River Created Kerfuffle."

340. Carter Lake Environmental Assessment and Rehabilitation Council, "Carter Lake Water Quality Management Plan," 1.

341. Schreier and Brownlee, "Sights and Sounds from Area Elections."

342. McMahon, "Greetings from Carter Lake."

343. Janovy, "Taking Off the Tarnish," 1.

344. Robbins, "Carter Lake Journal; Standing by a Capricious Neighbor."

# BIBLIOGRAPHY

Abourezk, Kevin. "For Tribes, Business an Emerging Battleground." *Lincoln Journal Star*, July 30, 2012.

Allin, Lawrence Carroll. "'A Thousand and One Little Delays': Training the Missouri River at Omaha, 1877–1883." *Nebraska History* 66 (1985). http://www.nebraskahistory.org/publish/publicat/history/full-text/NH1985Missouri.pdf.

Andersen, Laura. "C.L. Library Is Renamed to Honor Edward Owen." *Daily Nonpareil*, February 22, 1991.

Anderson, Julie. "Carter Lake Presses Its Casino Case." *Omaha World-Herald*, August 2, 1994.

Andreas, A.T. *History of the State of Nebraska*. Chicago: Western Historical Company, 1882. http://www.kancoll.org/books/andreas_ne/douglas/douglas-p24.html.

Arterburn, Joe. "Carter Lake Chief: Geography Is Cause of High Crime Rate." *Daily Nonpareil*, January 17, 1992.

———. "Iowa Panel Won't 'Swap' Carter Lake." *Daily Nonpareil*, August 14, 1990.

———. "No Warnings for C.L. Tainted Fish." *Daily Nonpareil*, November 18, 1990.

"Avulsion." Tropospheric Aerosol Library. http://theexclaves.com/avulsion.php.

Beerman, Brian James. "The History of the Mafia in Omaha." NebraskAmazing. http://nebraskarules.tripod.com/id50.html.

Boughn, Pete. "Man Fights Attraction." *Omaha World-Herald*, July 22, 1956.

Boyce, Brien T. "Carter Lake." *Daily Nonpareil*, October 26, 2004.

Boyer, Bill. "Whatever You Call Him, Mabrey Gets Action." *Omaha Sun*, August 5, 1965.

Brownlee, Mike. "FLOOD: Carter Lake Has Sandbags Ready to Go." *Daily Nonpareil*, June 14, 2011.

———. "Lake Closed This Week." *Daily Nonpareil*, September 27, 2010.

———. "Mayor Pushes for Grocery Store." *Daily Nonpareil*, May 19, 2011.

———. "Saving Carter Lake: Implementation of Restoration Plan to Begin." *Daily Nonpareil*, May 13, 2010.

Carter Lake Environmental Assessment and Rehabilitation Council. "Carter Lake Water Quality Management Plan." May 2008, 1. http://www.iowadnr.gov/portals/idnr/uploads/water/watershed/files/carterlakewmp.pdf?amp;tabid=771.

Coffey, Ashlee. "CBCSD Discusses Proposed Attendance Area for Walnut Grove Students." *Daily Nonpareil*, November 30, 2013.

Coulton, Dave. "Carter Lake Keeps Police Reserve Unit." *Daily Nonpareil*, February 10, 1976.

Council Bluffs Community School District. "History of the Council Bluffs Community School District." http://www.cb-schools.org.s3.amazonaws.com/wp-content/uploads/2013/06/HISTORY_OF_THE_SCHOOLS1.pdf.

Economic Research Service of the U.S. Department of Agriculture. "Food Access Research Atlas." http://www.ers.usda.gov/data-products/food-access-research-atlas/go-to-the-atlas.aspx.

Ehrlich, Daniel Henry. "Problems Arising from Shifts of the Missouri River on the Eastern Border of Nebraska." *Nebraska History* 54 (1973). http://www.nebraskahistory.org/publish/publicat/history/full-text/NH1973MissouriRiver.pdf.

Environmental Protection Agency. "Removal Activities to Begin, Former Carter White Lead Superfund Site, Omaha, Douglas County, Nebraska." *EPA.gov*, July 2012. https://archive.epa.gov/region07/factsheets/web/html/remvl_begin_frmr_carter_white_lead_spfd_omaha_ne.html.

Fahrenkrug, Glen. "Carter Lake Fire Department Seeks Funds for Replacement." *Daily Nonpareil*, February 11, 1974.

Faris, John. "Dr. Jefferis Turned to Herbs to Treat C.B. People." *Daily Nonpareil*, April 11, 1979.

———. "The Good Doctor Made Booze, Too." *Daily Nonpareil*, April 18, 1979.

———. "Jefferis Mill City's Cause for Celebration." *Daily Nonpareil*, April 4, 1979.

Field, Homer H., and Joseph R. Reed. *The History of Pottawattamie County*. Chicago: S.J. Clark Publishing, 1907.

Fletcher Sasse, Adam. "An Early History of Omaha's Carter Lake, aka Lake Nakoma, aka Cutoff Lake." *North Omaha History Blog*, September 28, 2013.

http://northomaha.blogspot.com/2013/09/a-waterfront-boardwalk-in-north-omaha.html.

————. "A History of Omaha's Pleasure Pier and Kiddieland." *North Omaha History Blog*, September 21, 2013. http://northomaha.blogspot.com/2013/09/pleasure-pier-and-kiddieland.html.

————. "A Short History of the Original East Omaha." *North Omaha History Blog*, January 6, 2016. http://northomaha.blogspot.com/2016/01/a-short-history-of-original-east-omaha.html.

Fogarty, Jim, and Annie Mumgaard. "Omaha's Gambling History." *Statewide*, Nebraska Educational Telecommunications, October 1, 2004.

Friend, Dennis. "The Missouri River Has Done This Before." *Daily Nonpareil*, June 5, 2011.

————. "School's in Session." *Daily Nonpareil*, August 17, 2011.

————. "What Happened to the Buildings?" *Daily Nonpareil*, September 23, 2009.

Fruhling, Larry. "Iowa's Town 'Over There' Suffers under Identity Crisis." *Des Moines Register*, February 7, 1988.

Groneweg, W.A., O.W. Crowley and H.B. Walling. "Iowa Boundary Commission to the Hon. John Hamill, Governor of Iowa." Letter. Council Bluffs Public Library Special Collections.

Harding, David. "Meandering River Created Kerfuffle." *Omaha World-Herald*, August 22, 2010.

Harvard Business School. "National Lead Company." Lehman Brothers Collection—Contemporary Business Archive. http://www.library.hbs.edu/hc/lehman/chrono.html?company=national_lead_company.

Hendricks, Mike. "Carter Lake Seeks Law Aid from Pott. County." *Daily Nonpareil*, October 25, 1979.

"Historic Floods on the Missouri River: Fighting the Big Muddy in Nebraska." Nebraska Department of Natural Resources. http://www.dnr.ne.gov/historic-floods-on-the-missouri-river.

Holbrook, Emily. "Historic Floods of the Big Muddy." *Risk Management*, August 1, 2011. http://www.rmmagazine.com/2011/08/01/historic-floods-of-the-big-muddy/.

Iowa Secretary of State's Office. "Incorporated Cities." https://sos.iowa.gov/business/pdf/IncCities.pdf.

"Iowa State Parks & Recreation Areas: 2011 Annual Report Supplement." Iowa Department of Natural Resources, May 1, 2012. http://www.iowadnr.gov/Portals/idnr/uploads/parks/pdfs/2011annualreportsupplement.pdf.

Janovy, Jena. "Taking Off the Tarnish—Carter Lake Getting Tired of Old Jokes Officials Say the City Is Erasing Bad Image." *Omaha World-Herald*, January 24, 1997.

Janson, Donald. "Iowa Is Called Aggressor State." *New York Times*, July 26, 1964.

Kaufman, Kirby. "Balancing Work and Family Part of a Volunteer Firefighter's Job." *Daily Nonpareil*, October 7, 2014.

———. "Carter Lake Fire Department Concerned with Accommodations, Equipment." *Daily Nonpareil*, June 11, 2014.

———. "DNR: 'No Easy Solution' for Carter Lake." *Daily Nonpareil*, October 22, 2013.

———. "DNR Says Grass Carp Won't Help Carter Lake Algae." *Daily Nonpareil*, September 13, 2013.

———. "Waltrip Ousts Kramer as Carter Lake Mayor." *Daily Nonpareil*, November 6, 2013.

———. "Water Rescue Are Services 'Essential' to Carter Lake." *Daily Nonpareil*, June 18, 2014.

Kelly, Michael. "Nephew Recalls 'Nebraska's First Lady of the Mob.'" *Omaha World-Herald*, July 13, 2014.

Koffend, John. "Suit Over 140 Acres Could Affect Development of Lake." *Omaha World-Herald*, January 1, 1952.

Kotz, Nick. "High Court Hears Iowa Border Case." *Des Moines Register*, January 26, 1965.

Larsen, Lawrence H., et al., *Upstream Metropolis: An Urban Biography of Omaha and Council Bluffs*. Lincoln: University of Nebraska Press, 2007.

Lehmer, Larry. "Carter Lake Library Moves to New Big 'Sagging' Home." *Daily Nonpareil*, October 13, 1973.

Leu, Jon. "A New Leader Under Pressure." *Daily Nonpareil*, May 22, 2016.

McAndrews, Kevin. "Iowa Loses Carter Lake in U.S. Census Forms." *Daily Nonpareil*, March 28, 1990.

McGinn, Mary Lou. "Home Owned by Dr. Jefferis—An Early Bluffs Settler." *Daily Nonpareil*, July 23, 2012.

McKee, Jim. "Jim McKee: Lake Manawa, Nebraska or Iowa?" *Lincoln Journal Star*, August 2, 2015.

———. "Jim McKee: Missouri River Has a Storied History of Flooding." *Lincoln Journal Star*, June 12, 2011.

McMahon, Tom. "Greetings from Carter Lake." *Daily Nonpareil*, August 1, 2004.

———. "On the Outskirts of Carter Lake, Iowa." *Daily Nonpareil*, August 1, 2004.

*Missouri v. Nebraska*, 196 U.S. 23 (1904).

Nation, Chad. "County 'Supports' Suit against Casino." *Daily Nonpareil*, September 11, 2008.

———. "Miller Files Lawsuit over Gaming Legality." *Daily Nonpareil*, August 23, 2008.

National Weather Service. "Historic Crests." http://water.weather.gov/ahps2/crests.php?wfo=oax&gage=omhn1&crest_type=historic.

Nebraska State Historical Society. "Carter White Lead Company (Omaha, Neb.)" http://www.nebraskahistory.org/lib-arch/research/manuscripts/business/carter-lead.htm.

Nell, Donald F., and Anthony Demetriades. "The True Utmost Reaches of the Missouri River." *Montana Outdoors*, July-August 2005. http://fwp.mt.gov/mtoutdoors/HTML/articles/2005/MissouriSource.htm.

*Nebraska v. Iowa*, 406 U.S. 19 (1972).

New World Encyclopedia contributors. "Missouri River." *New World Encyclopedia*. http://www.newworldencyclopedia.org/p/index.php?title=Missouri_River&oldid=985202.

Nielsen Lauritsen, May. "Recollections of East Omaha Dairies in the 20's." Council Bluffs Public Library Special Collections, n.d..

Offenburger, Chuck. "Mayor Ending Colorful Career at Carter Lake." *Des Moines Register*, November 5, 1973.

Parrott, Larry. "Carter Lake Residents Take Lots of Pride in Their Town—Over There." *Daily Nonpareil*, January 20, 1957.

———. "Electorate of Carter Lake Should Settle Boundary Row." *Daily Nonpareil*, August 31, 1958.

Patton, Donald K. "City Now in Step with Post Office." *Daily Nonpareil*, June 2, 1966.

———. "C.L. Wants More Than Stamp Store." *Daily Nonpareil*, June 25, 1965.

———. "Mabrey Ready to Step Out of Office—In Four Years." *Daily Nonpareil*, November 7, 1965.

———. "'Sold Down the River,' Carter Lake Opinion." *Daily Nonpareil*, December 22, 1960.

Peterson, Gary. "Board Turns Area Over to Carter Lake." *Daily Nonpareil*, January 25, 1994.

———. "Carter Lake Not Likely to Get Own Post Office." *Daily Nonpareil*, August 13, 1994.

———. "Carter Lake Says Crime Figures Show Town Safe." *Daily Nonpareil*, March 12, 1994.

———. "Carter Lake Sues Omaha Over Casino." *Daily Nonpareil*, August 9, 1994.

———. "Mabrey Recalls Carter Lake's Early History." *Daily Nonpareil*, September 6, 1994.

———. "Omaha's Claim Is Nothing New." *Daily Nonpareil*, April 21, 1994.

Pinter, Nicholas, and Reuben A. Heine. "Hydrologic History of the Lower Missouri River." *Great Rivers Habitat Alliance*, 2011. http://www.grha.net/site/wp-content/uploads/2011/04/hydrologic-history-of-the-lower-missouri-river.pdf.

Preserve Council Bluffs. "523 Sixth Avenue—Thomas Jefferis." http://preservecouncilbluffs.org/523-sixth-avenue/.

Robbins, William, "CARTER LAKE JOURNAL; Standing by a Capricious Neighbor." *New York Times*, April 21, 1988. http://www.nytimes.com/1988/04/21/us/carter-lake-journal-standing-by-a-capricious neighbor.html

Rohwer, Tim. "C.L. Council Approves Resolution about Casino Possibility." *Daily Nonpareil*, August 21, 2008.

————. "Omaha Company Ready to Finalize Carter Lake Location." *Daily Nonpareil*, September 11, 2014.

Rosenberg, Gary. "Grand Jury Criticizes Carter Lake Government." *Daily Nonpareil*, December 3, 1981.

Schreier, John. "Carter Lake's Colorful, Confusing History." *Daily Nonpareil*, August 27, 2012.

Schreier, John, and Mike Brownlee. "Sights and Sounds from Area Elections." *Daily Nonpareil*, November 6, 2013.

Shotwell, Walter. "Carter Lake Seeks Pledge That It'll Always Be in Iowa." *Des Moines Register*, February 5, 1961.

Simpson, Robert. *River Town: A Descriptive Survey of a Unique Community.* Omaha, NE: University of Omaha, 1960.

Smetana, Frank. *The History of Lake Manawa 1881–1981: Official Centennial Edition.* Council Bluffs, IA: Lake Manawa Centennial Committee and Council Bluffs Chamber of Commerce, 1981.

Smith Camp, Laurie. "Land Accretion and Avulsion: The Battle of Blackbird Bend." *Nebraska Law Review* 56 (1977). http://digitalcommons.unl.edu/nlr/vol56/iss4/3.

Stokes, Dillard. "House Votes to Keep Carter Lake in Iowa." *Daily Nonpareil*, April 13, 1961.

Stoltzfus, Katharine. "Cities Reach Land Agreement." *Daily Nonpareil*, September 20, 1994.

————. "Decision Dashes Dreams." *Daily Nonpareil*, January 27, 1995.

Sylvester, B.F. "Omaha's Flood, 1952." *Nebraska History* 35 (1954). http://www.nebraskahistory.org/publish/publicat/history/full-text/NH1954Omaha_Flood.pdf.

Taylor, Jonathan. "Officials Hope $840,000 Pipeline Will Stop Carter Lake Fluctuations." *Daily Nonpareil*, September 17, 1986.

Thomas, Fred. "Carter Lake Expects Community to Bloom." *Omaha World-Herald*, November 25, 1973.

Tobias, Mike. "'On the Wrong Side of the River': The Odd Story of McKissick Island, Nebraska." *NET News*, December 20, 2013.

White, Flo. "Long Ride Home for Carter Lake Backers." *Daily Nonpareil*, January 28, 1995.

Zimmerman, Ken. "Iowa Denies Violations of '43 River Compact." *Omaha World-Herald*, July 23, 1964.

# ABOUT THE AUTHOR

John Schreier is a native of Omaha, Nebraska. He has long had a deep passion for writing and history and graduated from the University of Nebraska–Lincoln with a bachelor's degree in journalism and a double major in history. This is his first book. Currently, John is the managing editor of the *Daily Nonpareil* newspaper in Council Bluffs, Iowa, where he resides with his wife, Samantha, and son, Leo. Some of John's other work can also be seen in *Sports Illustrated*, the *Denver Post* and the *Omaha World-Herald*.